D1283983

Transforming
Images

Transforming Images

Images

How Photography
Complicates the Picture

Barbara E. Savedoff

Cornell University Press
Ithaca and London

First published 2000 by Cornell University Press

Printed in the United States of America

Library of Congress Cataloging-in-Publication Data

Savedoff, Barbara E.
 Transforming images : how photography complicates the picture /
Barbara E. Savedoff.
 p. cm.
 Includes bibliographical references and index.
 ISBN 0-8014-3375-4 (cloth)
 1. Photography—Philosophy. 2. Photography, Artistic—Philosophy.
I. Title.
TR183.S29 1999
770'.1—dc21 99-37650

Cornell University Press strives to use environmentally responsible suppliers and materials to the fullest extent possible in the publishing of its books. Such materials include vegetable-based, low-VOC inks and acid-free papers that are recycled, totally chlorine-free, or partly composed of nonwood fibers. Books that bear the logo of the FSC (Forest Stewardship Council) use paper taken from forests that have been inspected and certified as meeting the highest standards for environmental and social responsibility. For further information, visit our website at www.cornellpress.cornell.edu

Cloth printing 10 9 8 7 6 5 4 3 2 1

This book is dedicated to my parents
Malcolm and Roberta Savedoff

and to the memory of my mentor, friend,
and colleague
Marx W. Wartofsky

Contents

Acknowledgments

I am fortunate to have many good friends and colleagues who have helped me develop the ideas in this book. The people I acknowledge here are those who were most central to the evolution of this work, but there are many others whose comments, probing questions, and enthusiasms have left their mark.

I want first of all to thank my teachers Jeremy Gilbert-Rolfe, with whom I studied painting, and Arthur Szathmary and Thomas Scanlon, with whom I studied philosophy at Princeton; Arthur Danto and David Hoy, with whom I studied at Columbia; and Bob Matthews, Laurent Stern, and Peter Kivy at Rutgers. I owe my development as a writer and philosopher of art to these dedicated teachers and mentors.

I also thank Sam Fentress for first introducing me to the work of Walker Evans many years ago and for sparking my interest in photography.

The idea for this book grew out of discussions with my students in aesthetics at Vanderbilt University and with my colleague Henry Teloh. Philip Alperson provided the first forum for the presentation of these ideas at a colloquium at the University of Louisville.

Some of the many people who contributed to the development of this book, in casual conversation or in formal commentaries, include Peg Brandt, Noël Carroll, Cheryl Foster, Alan Furbeck, Mary Geer, Lynn Jacobs, Anne Koenig, Patrick Maynard, Marshall Schneider, Joel Snyder, and Kristin Warbasse. The comments of Hilde Heine and Kendall Walton were especially helpful and greatly appreciated.

I owe special thanks to Susan Feagin and Tom Leddy, both of whom offered extensive valuable criticism at various stages; I am very appreciative of the time each devoted to the thoughtful reading of my work. I am also deeply grateful to my late friend and colleague Marx Wartofsky, whose generous support and encouragement, insightful comments and criticisms, unflagging optimism and good humor were a wonderful help and inspiration to me.

My editor at Cornell, Alison Shonkwiler, helped me enormously in all aspects of this project, from line-by-line suggestions to general guidance. I appreciate the time and energy she put into this book, and I am grateful for her patience with missed deadlines and her calm handling of difficulties. I am also grateful to my manuscript editor, Carol Betsch, for the care and thoughtful attention she gave this project, and to the many other people at Cornell University Press who helped see this book to completion.

I thank my husband, Harlan Kosson, for his patience and support throughout, but especially during the last, most difficult months of writing.

Finally, I must thank my parents, who have helped me with everything from editorial suggestions to sympathetic counsel. I am grateful to them for their confidence in me and for always encouraging me to follow my intellectual passions. They fostered my earliest education in art and critical thought, and they continue to be my most valued mentors.

This book was written, in part, with the support of a grant from the American Council of Learned Societies and of grants from the Professional Staff Congress of the City University of New York. Support was also contributed by the Philosophy Department of Baruch College. I thank the *Journal of Aesthetics and Art Criticism* for permission to publish portions of the following articles: "Transforming Images: Photographs of Representations," vol. 50, no. 2 (Spring 1992), pp. 93–106; "Looking at Art Through Photographs," vol. 51, no. 3 (Summer 1993), pp. 455–462; "Escaping Reality: Digital Imagery and the Resources of Photography," vol. 55, no. 2 (Spring 1997), pp. 201–214. I thank all the many institutions and individuals who have provided me with images and the permission to use them. I am particularly grateful to Jerry Uelsmann, to the Getty Museum, and to The Readers Digest Collection, for their exceptional generosity.

B. E. S.

The Familiar
Made Strange

Diverse circumstances can change the way we see the world around us, making the familiar strange to our sight. For instance, when flying in an airplane over our hometown we see the buildings, streets, rivers, and hills we encounter daily from an entirely different perspective. Although we know each feature within our view, it is only from an airplane that we can see what things look like from far above, that we can see the outlines and contours of vast tracts of land or the relative size and orientation of buildings that are miles apart. A similar, if less radical, change in the way we see a familiar landscape can be achieved by a fresh snowfall. Each tree, shrub, gate, and pathway may be well known, but each looks uncannily different traced in white.

Photographs, too, can make strange the familiar sights and objects of our world, although this is not usually how we think of them. Instead, we tend to think of photographs as providing us with records of how things look, and certainly this is the source of much of their pleasure and fascination. With photographs we can preserve important moments in our lives or hold in our hands images of events distant in time and place. Photographs acquaint us with things that would otherwise be inaccessible. But photographs do not simply record; their fascination is not simply that of preservation. Photographs transform their subjects. They have the power to make even the most familiar objects appear strange, the most chaotic events appear structured, or the most mundane items appear burdened with meaning. Photographs seem to reveal to us things that cannot be seen with our eyes alone.

There are many ways in which photographs accomplish these transformations. Unusual camera angles, dramatic lighting, and idiosyncratic cropping are but a few of the techniques available. For example, in Bill Brandt's *Nude, East Sussex Coast* (1959), the cropping of the image and the use of black and white make the subject, a nude, almost unrecognizable. The photograph shows an elbow resting on crossed legs; however, these elements become abstract shapes because their relation to the rest of the body is not shown and because there is no color to help us identify the mysterious surfaces as flesh.

The position of the camera is crucial to the impact of André Kertész's *Shadows, Paris* (1931). In this photograph, Kertész's use of a bird's eye view seemingly reverses the status of children and their shadows. Because of the unusual vantage point, the shadows have a prominence and lively presence that the children's figures lack: the shadows show us the shapes, postures, and dress of the children, who are themselves reduced to trailing, foreshortened, enigmatic

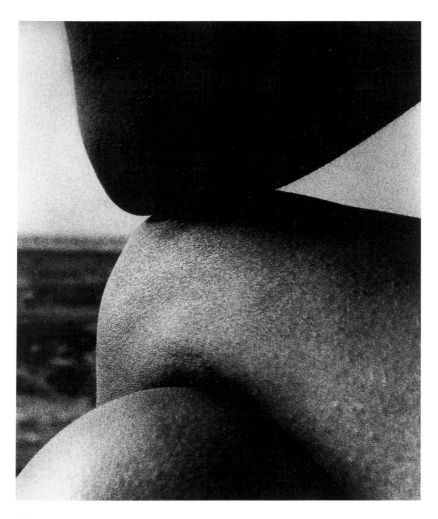

Bill Brandt

Nude, East Sussex Coast, 1959. Photograph. Bill Brandt © Bill Brandt Archive Ltd.

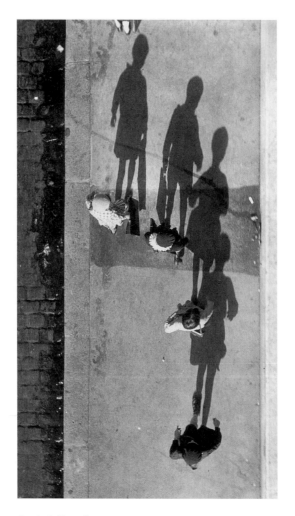

André Kertész

Shadows, Paris, 1931. Photograph.
© Estate of André Kertész.

children, who are themselves reduced to trailing, foreshortened, enigmatic specks.

The "making strange" of familiar objects can also be found in more documentary photographs, such as Barbara Morgan's *Martha Graham, Letter to the World (Kick)* (1940). Morgan's photograph freezes the motion of the dancer and the sensuous billows and folds of her dress, presenting an image of movement very different from what we would see in witnessing Graham dance. Graham seems to float as her right leg disappears beneath the graceful arc of cloth, but the extraordinary lighting and its dramatic effects in black and white give a tactile, almost sculptural quality to the image.

In order to better understand the medium of photography, we need to understand the nature of these transformations of subject matter. Toward this end, we must investigate the ways in which objects appear transformed and explore the features of photographs and the photographic process that account for these apparent transformations. It is useful to begin by narrowing our scope, looking at one category of change, which can then serve as a basis for a more general account of photographic transformation.

In this book, I have chosen to focus primarily on the way photographs transform works of art and other representations, on the way photographs can make a sculpted figure or a painted image seem alive. This focus is desirable not only because it will help throw greater light on the differences between photography and the other art media, and not only because some of the most compelling photographs have representations as their subject, but also because the photographic transformation of representations carries on in an extraordinary way an age-old obsession with the mysteriousness of images and with the possibility of

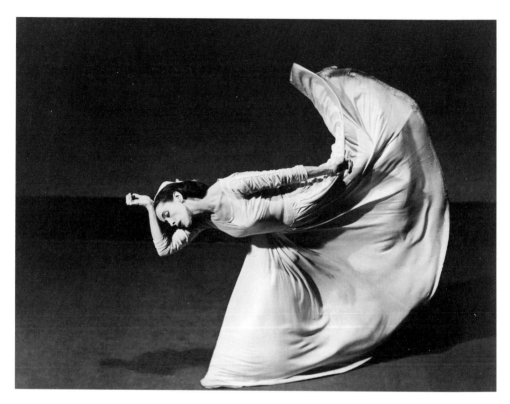

Barbara Morgan

Martha Graham, Letter to the World (Kick), 1940. Gelatin-silver print, $14^{3}/_{4} \times 18^{3}/_{8}$" (37.4 × 46.7 cm). By permission of The Museum of Modern Art, New York. John Spencer Fund. © Photograph by Barbara Morgan.

images coming to life. It is with the precedents of this obsession in literature and painting that I begin my investigation, so that later we can see more clearly what is distinctive about photography's treatment of this subject.

The idea of images coming to life goes back to earliest myths and legends. In Chapter 1, I examine paintings that explore this theme, not only through the outright illustration of such myths and legends, but also through the ambiguous liveliness with which they depict representations. This study not only tells us about a certain phenomenon within painting, it also provides us with a frame of reference for studying photographs of representations.

Like paintings, photographs of representations admit of ambiguity, made possible by the many ways in which photographs transform their subjects. But unlike paintings, photographs are seen as having a special connection with reality, and this gives the transformations of photography a compelling force and surreal power unavailable to painting. In Chapter 2, the conditions of photographic transformation are explored, as are the problems posed by photo-realist paintings, painterly photographs, and altered photographs. The comparison of these different cases shows that the special character of photographic transformation is linked to expectations growing out of our beliefs about the ways in which the photographic image is produced.

This difference between painting and photography can also be observed in the comparison of animated and live film. In Chapter 3, I discuss the obstacles and opportunities that live film affords for the ambiguous depiction of representations. A comparison of ambiguity and transformation in live film, in cartoons, and in films using special effects upholds the findings of the previous chapter—

that beliefs about the genesis of the image are central to the special power of photographic transformation.

Photographic transformations have particular significance for the reproduction of artworks. In reproduction, a painting or sculpture is reduced to its photographically transmittable properties. Despite its aura of objective accuracy, a photographic reproduction distorts the work it presents. Moreover, the widespread use of reproductions tends to obscure critically important differences between paintings and photographs, making invisible the very subject of this study. When photographs and paintings are studied in reproduction, the aesthetic differences between them are minimized, since paintings are presented in photographic form. These and related problems are discussed in Chapter 4.

The development of digital technology and the practice of digitally altering photographs challenge our assumptions about the manner in which photographs are produced; thus they not only imperil photography's documentary and journalistic functions, but also threaten a fundamental aesthetic distinction between paintings and photographs. The more common it becomes to digitize and alter photographs, the more freedom the photographer has to change and rearrange elements, the more the photograph becomes a construction—like a painting. In Chapter 5, I argue that the creative freedom provided by digital manipulation is bought at the cost of photography's distinctive power.

In summary, this book investigates how photography's perceived special connection to reality can account for its distinctive aesthetic impact and for the divergence in our readings of paintings and photographs. However, with the rise of digital imagery, this perception of a special connection is threatened, and we may find our aesthetic responses to photographs gradually, though inevitably and radically, altered.

1 | Ambiguous Images

There is a long-standing fascination, in literature and myth, with the idea that representations are alive or can come to life. According to Ernst Gombrich, there are legends and folk tales from all over the world "of images that had to be chained to prevent their moving of their own accord and of artists who had to refrain from putting the finishing touch to their paintings to prevent the images from coming to life."[1]

There are stories of animation in both biblical and classical literature. In Genesis, for example, God breathes life into a body fashioned from earth, and in Greek myth the sculpture Galatea comes to life in answer to Pygmalion's

prayer. Numerous accounts of miracles involving the animation of crucifixes and the images of saints appear in the Christian tradition, and in Jewish legend there is the animation of Rabbi Loew's Golem. Secular accounts of animation are found in children's stories and fairy tales. In Pinocchio, a puppet comes to life and eventually becomes a real boy. In the tales of Hans Christian Andersen, the protagonists are often live toys or figurines—a one-legged tin soldier, a china shepherdess and chimney sweep. The Snow Child in Hawthorne's short story, the statue of the Happy Prince in Oscar Wilde's fairy tale, and the Gingerbread Man in the children's story, all have life or come to life.

Variations on this theme can also be found in drama and ballet: in the animation of the statue in Molière's *Don Juan* and of the puppets in *Petrushka*, in the dream animations of the dolls in the *Nutcracker Suite*, and in the attempted animation of the doll in *Coppelia*. This last case is particularly interesting because instead of the doll becoming alive, a young woman becomes, through impersonation, a doll. In the ballet, the dollmaker Coppelius is trying to use magic to bring to life his treasured masterpiece, Coppelia, but unbeknownst to him, Swanilda has dressed herself in Coppelia's clothes and has placed herself in the doll's chair. She first impersonates the lifeless doll and then counterfeits its animation.

The fascination with the animation of sculpted objects and painted images can be found not only in literature and ballet, but also in the visual arts themselves, most blatantly in illustrations of the Pygmalion theme (by Gérôme, Burne-Jones, Daumier, and others) and in medieval manuscript illuminations of miracles. But such literal illustrations of the theme are comparatively rare.

More common are paintings that toy with the idea of animation by depicting painted and sculpted figures as though they were live beings. In such paintings the distinction between "real" and "represented" is blurred.

Representations that are depicted as animate have an ambiguous status: although we may recognize them as depictions of paintings and sculptures, they do not function simply as paintings and sculptures within their compositions. They function in some ways as the objects or beings they represent. In this chapter, I discuss this ambiguity as it is found in Western painting from the Renaissance through Postimpressionism. I argue that although ambiguity can be found throughout this period, Postimpressionism marks a change in the way it is achieved and a change in the role it serves, and that this shift reflects an altered stance toward the classical theme of Pygmalion and Renaissance ideals of illusionism.

Gestural Ambiguity

The depiction of artworks can be found in paintings of diverse periods and genres, from Renaissance altarpieces to Postimpressionist paintings. The depicted artworks are often used to introduce motifs into the paintings, to complicate their compositional organization, or to provide formal and thematic correspondences with the "real" objects depicted.

It is easy enough to find analyses that discuss these functions of the depicted work. For instance, Arthur K. Wheelock Jr. describes the function of the painting represented within Vermeer's *Woman Holding a Balance* as follows:

Behind the woman looms an awesome painting of the Last Judgment. Painted in mute blacks and ochers, it acts as a compositional foil to the scene taking place before it. Its dark rectangular shape, with its horizontal and vertical emphasis, establishes a quiet stable framework against which Vermeer juxtaposes the figure of the woman. The visual association of the woman and the Last Judgment is reinforced by thematic parallels: to judge is to weigh. Christ, his arms and hands raised, sits in majesty on the Day of Judgment. His gesture, with both arms raised, mirrors the opposing direction of the woman's balance. His judgments are eternal; hers are temporal. Nevertheless, the woman's pensive response to the balance she holds suggests that her act of judgment, although different in consequence, is as conscientiously considered as that of Christ behind her.[2]

In Vermeer's painting the distinction between the "painted" scene and the "real" objects of the room is clearly marked. The forms of the painting within the painting are flat, indistinct, and muted, compared with the "real" objects that are depicted. The painting within the painting complicates the meaning and enriches the composition of Vermeer's work while remaining unquestionably a painting. But in some artworks the boundary between representations and real things is not so carefully observed, and the artist presents us with entities of an ambiguous status.

In a loose sense all paintings of artworks possess some degree of ambiguity. The depiction of a painted or sculpted figure serves many of the same functions that the depiction of a real person would serve. For instance, even in the Vermeer, we respond to the gesture of the painted Jesus as a *gesture*, not as a flat, inanimate pattern of paint, although we have no doubt that we are only looking at the painting of a painting. That is, the upraised arms have a dynamic effect

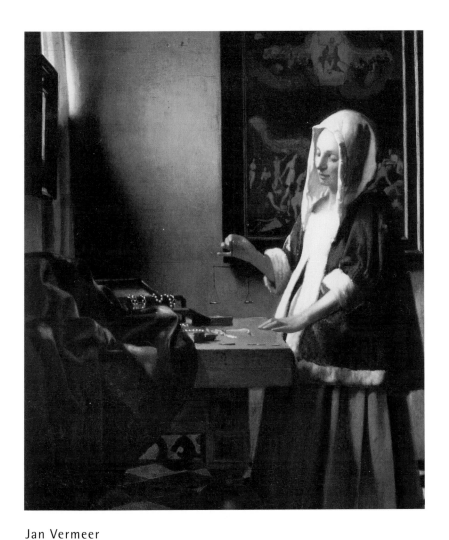

Jan Vermeer

Woman Holding a Balance, c. 1664. Oil on canvas, 16³/₄ × 15" (42.5 × 38 cm).
© 1998 Board of Trustees, National Gallery of Art, Washington, D.C. Widener
Collection.

that would not be fully preserved by a similar, but abstract, form. A stronger example of this appears in Judith Leyster's *Self-Portrait,* where the pose of the man in the depicted painting loosely mirrors Leyster's own and his gaze holds our attention almost as much as hers, even though he is clearly only an image on her unfinished canvas.

Numerous paintings of statues have the same effect. In Pannini's *Interior of the Pantheon,* the statues are clearly depicted as statues, yet their postures and gazes serve to direct our attention as though they were "real" human beings. And even in *The Baptism of Clovis* by the Master of St. Giles, the statue, although it is almost completely obscured and neither its hands nor face are visible, serves to counterbalance, by facing to the left, the crowd of people facing to the right.

However, what I want to discuss here are cases where the ambiguity is enhanced, where the confusion between the real and the represented is intensified. Such intensification occurs with the use of what I will call "gestural ambiguity." Ambiguity of this type is found frequently in Northern Renaissance and late Italian Renaissance paintings, and more sporadically in seventeenth- and eighteenth-century paintings of both Italy and the North. In these paintings, figures that are given the placement and coloring of stone statues are at the same time given the expressive aspect or functions of living beings. These paintings present us with a kind of animism—artworks are depicted as though they were alive, they are shown as though they were capable of movement and emotion.

For example, sculptures can be given expressions and poses that make them seem to react to their surroundings. In Botticelli's *Calumny of Apelles,* the allegorical figure of Innocence is shown as he is brought before an ass-eared king. The columns and arches that form the architectural backdrop for the scene are

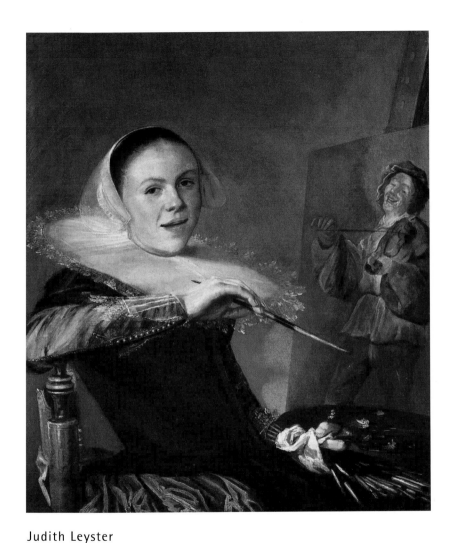

Judith Leyster

Self-Portrait, c. 1630. Oil on canvas, $29^{3}/_{8} \times 25^{7}/_{8}$" (74.6 × 65.7 cm). © 1998 Board of Trustees, National Gallery of Art, Washington, D.C. Gift of Mr. and Mrs. Robert Woods Bliss.

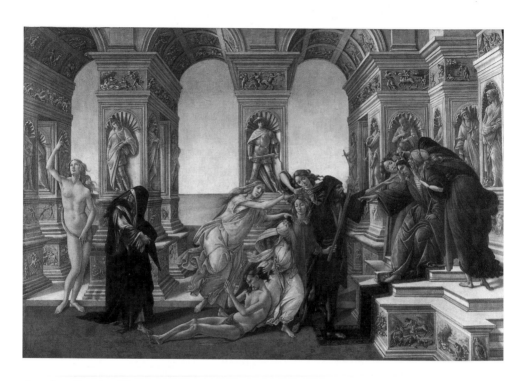

Sandro Botticelli

The Calumny of Apelles, 1495. Tempera on wood, 62 × 91 cm. Uffizi, Florence.
Erich Lessing / Art Resource, New York.

decorated with friezes, and each column also has niches for sculptures. The sculptures are the color of stone, but some seem to strain their necks to look at the scene from within their niches in the manner that living spectators would. The statues are clearly depicted as statues, but they also seem to have life—they have the expressions and gestures of living human beings.

A similar technique can be found in Pieter Jansz Saenredam's *Cathedral of Saint John at s'Hertogenbosch.* At first glance, the cathedral looks empty, peopled only by the statues lining its wall and by the altarpiece. As with the Botticelli, though, the statues (especially the ones to the left) seem to be straining their necks and tilting their heads to see the statues adorning the altar. They take the place of human figures. But in addition to the statues and the altarpiece, there is one other human form, that of a churchman kneeling on the left, partly obscured by the architecture. Although he is the only real person in the cathedral, his is the figure that least serves as a person. This is because, although we can see the face of every sculpture, the face of the man is completely hidden from us. Furthermore, his white cloak serves to bring him into conformity with the statues. Saenredam comes close to reversing the relative status of statues and person: the statues are presented as animate beings, while the person's animate character is hidden and muted.

This ambiguity in the depiction of artworks and the reversal of the relative status of person and statue are far from anomalous. They are found with the earliest widespread depiction of artworks in Western painting. Paul Phillipot writes that the depiction of statues within paintings became prevalent during the fourteenth and fifteenth centuries with the appearance of grisaille figures on the exterior panels of Northern Renaissance altarpieces. According to Phillipot, gri-

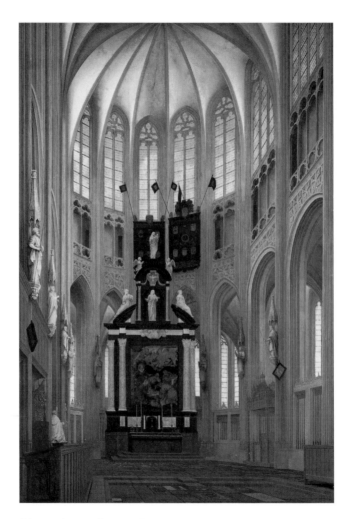

Pieter Jansz Saenredam

Cathedral of Saint John at s'Hertogenbosch, 1646. Oil on panel, $50^{5}/_{8}$ × $34^{1}/_{4}$" (128.8 × 87 cm). © 1998 Board of Trustees, National Gallery of Art, Washington, D.C. Samuel H. Kress Collection.

saille was introduced to address the problem of depicting sacred individuals in a manner that would distinguish them from secular ones, but would respect the realism of the picture and even enhance that realism by creating a trompe l'oeil continuity between architectural space and picture space.[3]

Previously, the difference in status between sacred and secular was conveyed by a difference in scale—the donors appearing much smaller than the holy personages—or by architectural separation—the donors appearing outside the enclosures that sheltered saints, angels, or the holy family. Both methods are evident in *The Annunciation* of the fifteenth-century *Beaufort Hours*, which shows two small donors kneeling outside the structure sheltering Mary and the angel. With the unification of space in the increasingly realistic paintings of the fifteenth century, these means of differentiation were no longer acceptable. According to Phillipot, the use of grisaille in depicting saints, angels, and the holy family, which gave them the coloring of stone statues, together with their placement as statues in niches, allowed for the presentation of holy personages and donors together in a unified picture space, while preserving the difference in status between them. So, for example, in Memling's *Virgin, Saint George, and Donors*, one panel shows a donor kneeling before a niche housing a grisaille figure of the Madonna and child, while the other shows a donor kneeling before a niche in which stands a grisaille figure of St. George. In van Eyck's *Ghent Altarpiece*, the bottom row of exterior panels shows kneeling donors flanking the grisaille figures of John the Baptist and John the Evangelist on pedestals.

The grisaille figures in these altarpieces have the coloring of stone, but the way the figures are rendered and the way they interact with their environment show that they are not to be understood as mere stone. This is particularly evi-

dent in a painting like Hugo van der Goes's *Annunciation*, the exterior panels of his Portinari Altarpiece. One panel shows a dove hovering over the gracefully seated Mary, the other shows a rather dynamic angel, arms raised and knees bent as if alighting from above. The fluidity of the drapery and gestures, along with the flying dove, conflict with the notion that these figures are made of stone. "The figures are animated with a movement irreconcilable with their apparent status as statues."[4] The figures are represented as statues, but they are not represented as inanimate. Furthermore, insofar as a fusion of image and prototype is entertained, grisaille images of saints, angels, and other holy personages, far from representing inanimate matter, represent entities of a higher ontological status than do the full-color images of people with which they are often juxtaposed.

Illustrations of Animation

That such a fusion of image and prototype has been widely entertained is shown by the numerous accounts of miracles involving the "live images" of saints and other sacred individuals. In his book *The Power of Images*, David Freedberg recounts scores of these legends of icons that bleed when struck, statues that strike straying nuns, and images of the Virgin that weep and sweat oils.[5] In a particularly engaging example, an artist-monk painting a Last Judgment is pushed off his scaffolding by an extraordinarily hideous picture of Satan he has just finished. The monk is saved by a painting of the Madonna, which stretches out her right arm, and together with her child, prevents him from falling.[6]

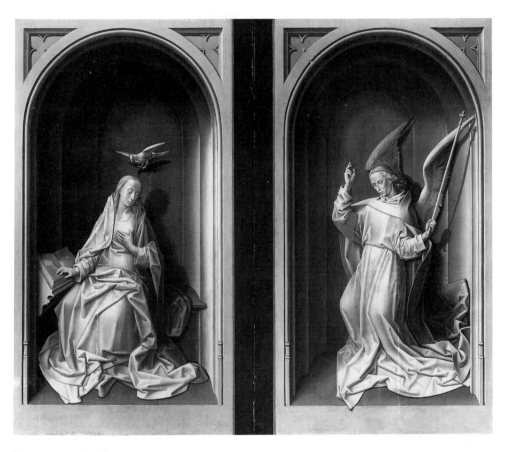

Hugo van der Goes

The Annunciation, c. 1476, from the outside panels of the Portinari Altarpiece, Uffizi, Florence. Alinari / Art Resource, New York.

Freedberg notes that these legends of live images are illustrated in manu-
scripts of the same period. Satan pushing the artist is represented in *Cantigas* of
Alfonso X and in *Miracles de Notre Dame*. The latter manuscript also provides an
illustration of a picture of the baby Jesus reaching out from its picture-space to
accept an apple from a little boy. It is important to note, however, that even
though these illustrations show live images, they are not ambiguous in the man-
ner of the paintings previously discussed. They depict sculptures or paintings as
actually animate, not sculptures or paintings of ambiguous status.

The Pygmalion illustrations also fail to depict sculptures of an ambiguous sta-
tus. Rather, they depict a sculpture undergoing a change of status. For instance,
in Jean-Léon Gérôme's *Pygmalion and Galatea*, in which the statue is shown in
the process of being brought to life by Pygmalion's embrace, Galatea's upper
body is flesh while her legs are still marble. In this painting, the statue is unam-
biguously shown to be in the process of actually coming to life. We are not
shown a statue of ambiguous status, a statue that functions as a person, but a
statue changing into a person.

Similarly, in René Magritte's *Discovery*, we are shown a woman who is a mys-
terious hybrid of flesh and wood. Though mysterious, she is not ambiguous.

In the Gérôme and the Magritte, the entities represented are freaks that fall
between classes of objects. In the one a statue is changing into a person, in the
other we see a surreal mixture of flesh and wood. But neither image is ambigu-
ous in the way I use the word in this chapter; neither painting shows one type of
entity (a painting or sculpture) with the status of another (an animate being).
The sculptures that appear in the Botticelli and the Saenredam are difficult to
classify not because they show a monstrous mixture, half-human/half-statue,
and not because they are in the process of change, but because we can under-

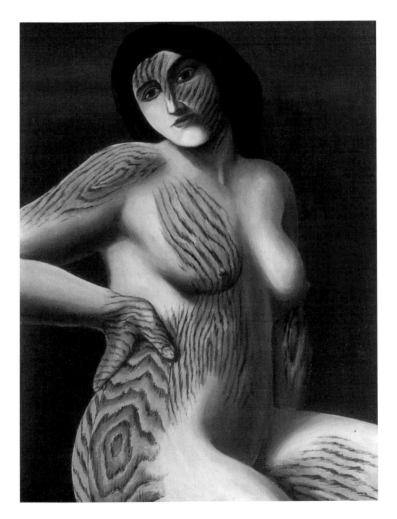

René Magritte

Discovery, 1927. Oil on canvas, 65 × 50 cm. Private Collection, Brussels.
Herscovici / Art Resource, New York. © 1999 C. Herscovici, Brussels /
Artists Rights Society (ARS), New York.

and not because they are in the process of change, but because we can understand the figures in both ways, as statues *and* as human beings.

Perceptual Ambiguity

Ambiguity can also be achieved in a second way: when artworks and "real" things are painted in the same manner, the distinction between them is blurred. This type of ambiguity, found frequently in Postimpressionist paintings of paintings, is what I will call "perceptual ambiguity." Theodore Reff touches on this phenomenon in his article on Cézanne's pictures within pictures. Reff discusses *Still Life with Plaster Cast*, which shows a plaster cupid on a table amid fruit and onions. In the background are several paintings, including one of a plaster cast and one of a still life.

> Playing with coincidences and paradoxes to a greater extent than usual . . . Cézanne merges the blue drape on the table with the same drape in the painting behind it; almost obliterates the horizontal edge of the table, while stressing the diagonal where the painting meets the floor; and fits the stem of the onion, neatly cut by the same diagonal, into the leg of the painted table directly above it. Through these means, he blurs the distinction between real and represented objects, assimilating all of them into a pictorial construction, highly contrived in places, more apparently natural in others, whose artfulness seems especially appropriate in a still life dominated by works of art. In combining a "real" drape and apples with "painted" ones, a "real" cast with a "painted" copy of one, he creates a series in which the degree of reality de-

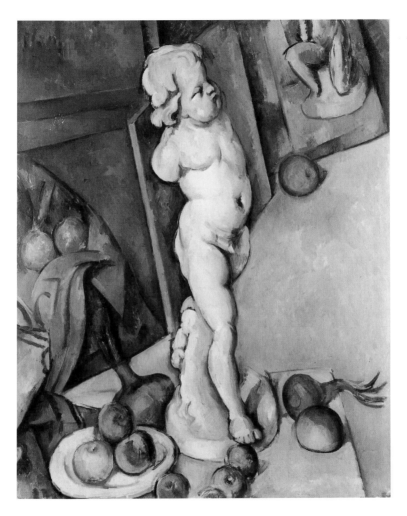

Paul Cézanne

Still Life with Plaster Cast, c. 1894. Oil on canvas. Courtauld Gallery, London.

creases steadily from the whole and vividly colored fruit in the foreground to the fragmented and nearly colorless copy in the background. Here the pictorial quotation is more than a compositional or metaphorical device; it is the basis for a meditation on the relation of the artificial and natural in Cézanne's mature art.[7]

Cézanne's *Peaches, Carafe, and Personage* presents an even more intriguing case. Reff explains that the status of the person shown in the background of the painting is unclear. He argues that it is neither a man seated in an adjacent room nor a mirror image, but a painting. But because of the similarities between the table depicted in that painting and the "real" table in the foreground, the depicted painting "also functions as a mirror, 'reflecting' part of the foreground and projecting it into the background."[8]

Perceptual ambiguity is created by depicting paintings (or sculptures) in a manner similar to their surroundings, and by minimizing any difference in coloring or distinction in brushwork. It can also be facilitated by an agreement in scale between the depicted work and its surroundings and a minimizing of visual clues, such as the disguising of the frames or edges of paintings.

This happens to some extent in Seurat's *Models*, which shows three women in a corner of his studio, with *La Grande-Jatte* filling the wall on the left and four smaller indistinct paintings and drawings displayed on the right.[9] *La Grande-Jatte* is presented as sharing more with the real space of the studio than with its fellow paintings. For one thing, the scale of its figures corresponds fairly closely to the scale of the figures in the studio. For another, *La Grande-Jatte* is cropped by the painting, with only two edges of its discreet white frame visible, one meeting the edge of the floor and the other marking the juncture of

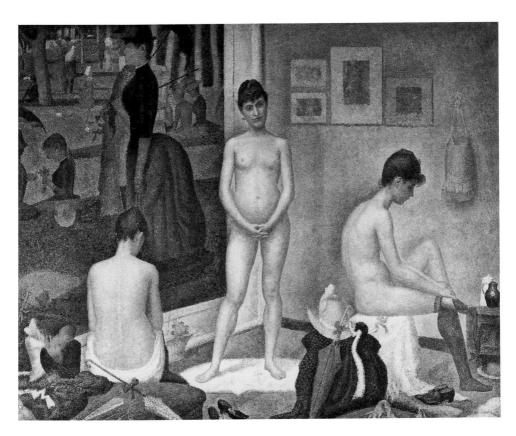

Georges Seurat

The Models, 1886–88. The Barnes Foundation, Merion Station, Pa. BF# 811, Gallery no. I. Photograph

the two walls, like the molding of a huge window opening up onto the studio. Alain Madeleine-Perdrillat notes the "encroaching presence of the *Grande-Jatte*" which he describes as "a false window and true large looking-glass into which reality disappears."[10] Thirdly, the depicted painting and the studio are treated somewhat uniformly by Seurat's brush (especially in his second small version), so the painting, with its greater saturation of color, very successfully competes with the real space of the studio. Finally, the nude women in an artist's studio seem to be more of the realm of art than the bourgeois citizens in their Sunday best out for a promenade. *The Models* thus represents a reversal of usual circumstances of display—bourgeois viewers in a real (gallery) space, nudes in paintings on the walls. All this gives *La Grande-Jatte* an ambiguous status within the painting and accounts for the shock one might initially have at first viewing *The Models*, with its mix of dressed and nude figures reminiscent of *Déjeuner sur l'herbe.* It is the central nude, engaging us with her eyes, that prevents the bourgeois figures of *La Grande-Jatte* from achieving full equivalence.

The Models provides an intersection of spaces, one a painted and the other a real space. A similar intersection occurs in Matisse's *Nasturtiums and "The Dance."* This painting shows an interior with a chair and a vase of nasturtiums resting on a stool; Matisse's painting, *The Dance,* fills the background. *The Dance* extends beyond the boundaries of the composition so that only its bottom edge is visible—and even that is not clearly identified as an edge since the blue of the background of *The Dance* blends with the blue of the room's floor, unifying the spaces of painting and room. Further unifying the two spaces is the fact that the scale of the painted dancers is reasonably close to that of the room. Indeed, the dancers look as though they could easily leap out of their

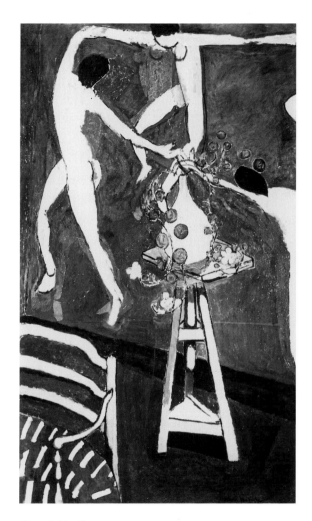

Henri Matisse

Nasturtiums and "The Dance," 1912. Oil on canvas,
75³/₄ × 45". © 1999 Succession H. Matisse, Paris / Artists
Rights Society (ARS), New York. Courtesy of Scala / Art
Resource, NY.

painting and into the room in which they hang, for no distinction made by Matisse in his treatment of the real and painted spaces prevents the idea of such interaction.

Uses of Ambiguity

By now it should be apparent that there are not only different ways of achieving ambiguity in paintings of artworks, but also vastly different purposes that these ambiguities can serve. In paintings from the Renaissance to Impressionism, ambiguity is used to further an ideal of illusionism in art: the artwork is shown as capable of life or at least of being confused with real things. This kind of ambiguity facilitates the animation of depicted artworks without casting doubt on the ontological status of the "real" things depicted. In Postimpressionism, however, ambiguity is used to opposite effect: to undermine any tendency of the painting toward illusionism and to undercut the status of the "real" things depicted.

The gestural ambiguity found in Renaissance paintings most commonly is attached to depicted sculptures or reliefs. By giving statues expressions and gestures that mimic those of the people represented, formal correspondences and a compositional unity can be achieved. Furthermore, the animism that results from giving lifelike expressions to statues contributes to the emotional content of a painting. A row of expressive spectator-statues, such as those found in *The Calumny of Apelles,* can serve the same function as the human spectators or the angel spectators of earlier Renaissance works, such as those found in Giotto's *Lamentation* in the Arena Chapel. Animate statues serve to diffuse expressive-

ness throughout the painting. Animate statues and reliefs can also introduce a story that complements or reinforces the main subject of the painting, while remaining subordinate to it. For example, in Petrus Christus's *Nativity* the themes of Adam and Eve and of Cain and Abel are introduced via the "animate" relief of the arch enclosing the nativity scene.

Finally, the ambiguity with which an image is presented can be used to convey something about the nature of the image itself, as in Hans Memling's depiction of Saint Veronica holding her cloth with the image of Jesus on it. This last example not only shows the (rare for a Renaissance artwork) attachment of ambiguity to a two-dimensional image, but also shows the extent to which Renaissance paintings could also make use of perceptual ambiguity.

The face on the cloth in Memling's *Saint Veronica* is like the face of the saint in color and execution—it is perceptually ambiguous. Furthermore, it shows gestural ambiguity insofar as the gaze of the image of Jesus engages us directly, unlike the gaze of the saint herself, who is shown with averted eyes. This makes the image of Jesus appear more animate, more powerfully present, than the saint. But the ambiguity here seems suited to the mystery surrounding the genesis of the image on the cloth. The ambiguity in the depiction of the image matches an uncertainty about the status of that image: is it a depiction of Jesus or an emanation of sorts? Is it merely a representation or something more?

The mystery surrounding Veronica's cloth corresponds to the mystery lent all art by the Pygmalion theme and by ideas of illusionism. These encourage us to see artworks as more than lifeless images. Postimpressionist paintings of artworks, with their emphasis on the artificiality of the image, thus mark a radical departure in perspective.

The perceptual ambiguity of Postimpressionist paintings usually attaches to

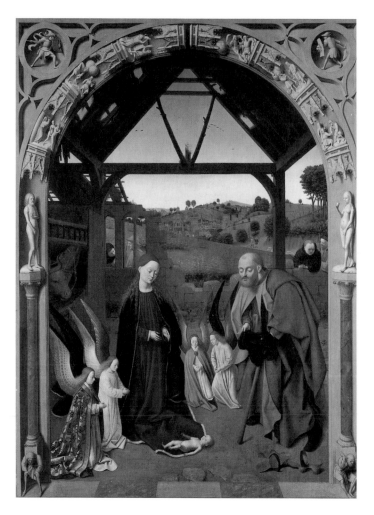

Petrus Christus

The Nativity, c. 1450. Oil on panel, $50^{1}/_{4} \times 37^{3}/_{8}$" (127.6 × 94.9 cm).
© 1998 Board of Trustees, National Gallery of Art, Washington, D.C.
Andrew W. Mellon Collection.

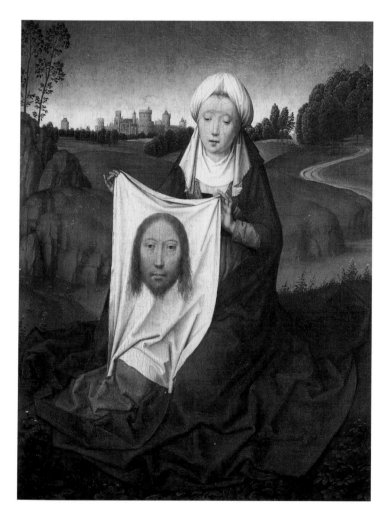

Hans Memling

Saint Veronica (obverse), c. 1470/1474. Oil on panel, 11¹⁵/₁₆ × 9" (30.3 ×
22.8 cm). © 1998 Board of Trustees, National Gallery of Art, Washington,
D.C. Samuel H. Kress Collection.

depicted still life, figure, or landscape paintings. The depicted artwork is often used to create formal correspondences with the "real" objects and to promote compositional unity through the repetition of motifs. But unlike the most common examples of Renaissance gestural ambiguity, Postimpressionist perceptual ambiguity generally serves to *hinder* the subordination of "painted" objects or motifs to "real" ones. When the "painted" fruit is almost as vivid as the "real" fruit that is shown, the similarities between the two serve not only to make the "painted" seem "real," but also to make us all the more aware that the "real" is also only painted. For when the two-dimensional "painted" objects are equated with the "real" objects, the actual flatness of those "real" objects is suggested and the illusion of pictorial space is undercut. This, of course, only furthers an attack on illusion already initiated by the painterliness and flatness of Postimpressionist technique. In these paintings any attempt to distinguish the "real" from the "represented" backfires, insofar as the similarities between them remind us that the "real" is also merely a representation.

Beyond Ambiguity

This undermining of the distinction between real and represented can be taken to greater extremes, quite explicitly in the paradoxical paintings of Magritte and more subtly in a painting by Ingres. But just as ambiguity serves different purposes before and after Impressionism, the breakdown of the distinction between real and represented serves different purposes that reflect different interests. The undermining of the distinction is used to undercut illusion in Magritte, but it still serves the mystique of the lifelike image in Ingres.

Magritte's *Human Condition*, which depicts a painting on an easel in front of a window, exhibits perceptual ambiguity: the depicted painting is painted the same way as its "real" surroundings, so as to make it stylistically continuous with them. But the depicted painting is not only stylistically continuous; the landscape it shows is also exactly continuous with the "real" landscape seen behind it through the window—even the clouds of the easel painting match up exactly with the "real" clouds in the sky. Can we distinguish between "represented" and "real" clouds when the two are depicted as so inseparable?

An even more complex example of this undermining of the distinction can be found in Magritte's *Attempting the Impossible*. At first it might appear that this painting, which shows a man in the process of painting a woman of ambiguous ontological status, is just a painter's version of the Pygmalion theme. The painting makes use of perceptual ambiguity, for Magritte depicts the woman with the same brushwork and in the same palette that he depicts the man. Although the woman is presented as a painting, or at least as something being painted, her appearance is very similar to that of the man painting her. However, the relations in Magritte's painting are more puzzling than they might initially seem. There is no canvas represented in the picture; there is no surface to which the man applies the paint or from which the woman can emerge. The paint must be imagined to become flesh as it touches the air—a process more mysterious than Pygmalion's, for we are dealing not only with an image come to life, but with one that is created in a most unfathomable way.

We can also read this painting in another manner. The canvas on which the man is painting and from which the woman is brought to life is the same canvas that supports the figure of the man. The difficulty here results from the fact that although we see we must identify the woman as, in some sense, a painting, we

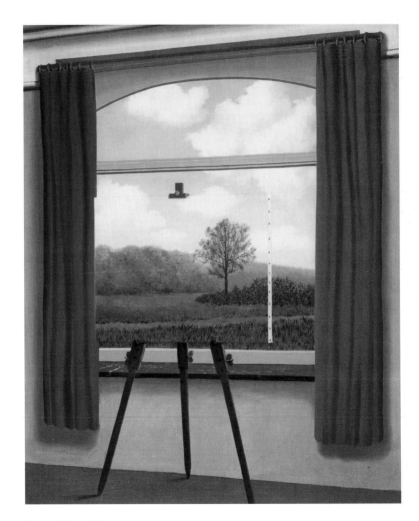

René Magritte

The Human Condition, 1933. Oil on canvas, 39³/₈ × 31⁷/₈" (100 × 81 cm). Courtesy of the National Gallery of Art, Washington, D.C. Gift of the Collectors Committee [1987.55.1]. © 1999 C. Herscovici, Brussels / Artists Rights Society (ARS), New York.

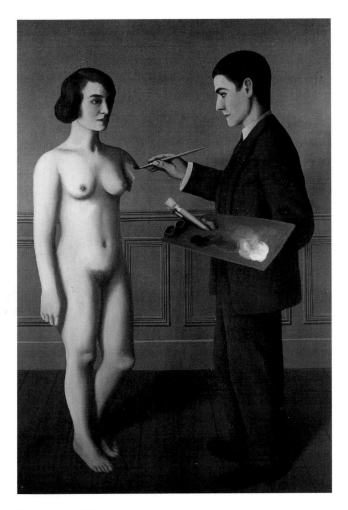

René Magritte

Attempting the Impossible, 1928. Oil on canvas, 116 × 81.1 cm.
Courtesy Galerie Christine et Isy Brachot, Brussels. © 1999 by
C. Herscovici, Brussels/Artists Rights Society (ARS), New York.

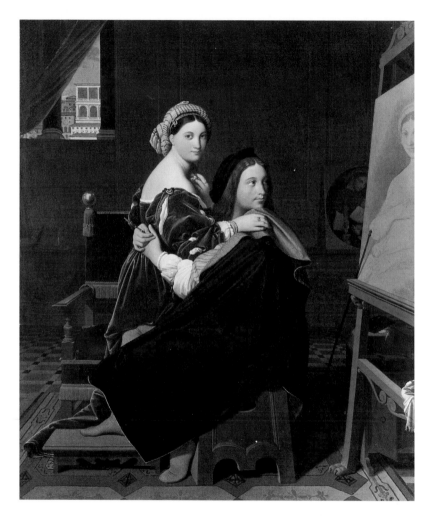

Jean-Auguste-Dominique Ingres

Raphael and the Fornarina, 1811–1812. Oil on canvas, 64.77 × 53.34 cm. Courtesy of the Fogg Art Museum, Harvard University Art Museums, Cambridge. Bequest of Grenville L. Winthrop.

cannot locate where the painting is; there is no canvas on which she emerges except the one which she shares with the "real" man. Thus our identification of the woman as a painting eventually undermines the illusion of the man's reality.

The undermining of the distinction between real and represented can also be found in Ingres's *Raphael and the Fornarina*, where there is an ambiguity and play between the woman seated on Raphael's knee and her depiction in a sketch on the easel. The ambiguity is not simply a result of the similarity in features and expression between the woman and her depiction, for after all, a clear distinction is made in the way the two are executed; rather the ambiguity is set up by Raphael's gaze.

When looking at the picture we are drawn at first to the "real" Fornarina gazing at us from the central portion of the canvas. But our attention is diverted by Raphael, who, instead of looking out at us or up at the woman he holds, directs his attention behind to the half-finished picture of the woman on the easel. Raphael looks at her as though at another woman. The effect of this is disturbing. We, too, find our attention diverted to the depiction on the far right side of the composition, until we are called back to the center by the gaze of its model. But the composition is disturbing not simply because it disrupts our gaze and forces us to keep moving from one figure to the next. We recognize a parallel between Raphael's gaze and ours, his rapt attention to the depiction is not unlike ours to the "real" woman, and the comparison reminds us that the "real" woman is also only a depiction. Real and depicted are made equivalent not simply by visual similarity, but by serving in similar relations. The "real" serves our gaze as the depicted serves Raphael's.

But with this analogy, the reality of Raphael is not undercut; Raphael is compared to the actual viewer of Ingres's painting. Perhaps, then, we can see the

comparison between the real and depicted woman not so much as a means of undercutting the illusion of Ingres's painting but as a means of illustrating the power of images. Raphael's drawing engages him more than the woman he holds. We can thus see Ingres's painting as saying something about the *true* object of Raphael's desire. If so, this last example, far from destroying illusion, actually carries through the theme with which we began. It provides us with yet another illustration of Pygmalion-like longing—and transformation.

Ambiguity in Photography

> If the plastic arts were put under psychoanalysis, the practice of embalming the dead might turn out to be a fundamental factor in their creation. —André Bazin, "The Ontology of the Photographic Image"

Closely allied to the idea of animation is the idea that image or inanimate matter was once alive. The theme of person becoming lifeless image, though far less common than that of animation, is also to be found in ancient myth. In Greek mythology, Midas, to his horror, turns his daughter to gold, Niobe weeping for her slain children is turned to stone, and Medusa petrifies all who see her, so that her dwelling is surrounded by the frozen figures of people and animals. In more contemporary literature, the witch in C. S. Lewis's *Chronicles of Narnia* turns people into statues. These examples are the reverse of animation because they present statues as bodies that have been drained of life, but are preserved, frozen, embalmed. (A story in Roald Dahl's *Witches* provides a chilling twist on

this theme: a young girl is turned into a figure in a painting, but one that grows older year by year until, having reached old age, it finally vanishes.)[11]

Death provides a literal example of the reverse phenomenon, insofar as it transforms a living body into inanimate matter. But what makes the reverse phenomenon terrifying is the preservation of the body. Preservation (as in embalming) may have originated as an effort to cheat death, saving the body from deterioration and enabling the body to be saved for veneration or for rituals of respect. Nevertheless, preservation, especially the instantaneous preservation of myth, also forcefully illustrates the brute reality of death, the final suspension of movement, breath, life (or worse, the imprisonment of life in a frozen body). If Medusa's victims had vanished in smoke, the story would not seem quite as eerie.

But there is another idea that corresponds to the reverse phenomenon—the idea that an image can somehow be left behind by the body. The legend of Veronica gives an example of this notion. When Veronica holds her cloth to wipe the face of Jesus, the cloth retains his image. The creation of the image on the cloth is meant to be seen as miraculous. Nevertheless, there is a whole class of images that really do preserve direct impressions of the dead and the living. Nature gives us fossils, art gives us body casts and death masks. These images do not preserve the body itself, but they do preserve a trace of the body.

There is a sense in which all portraits, both sculptural and pictorial, preserve a trace of the body. The process may be more indirect than the one that produced Veronica's cloth image, but all portraits "take" the image of the model, and figuratively preserve the body, by preserving its likeness. So we can use the legend of Veronica as a metaphor for all figurative art.

But there is a difference between casts, on the one hand, and sculptures and paintings, on the other: casts provide a direct record. Although flesh does not *become* the image, it does *create* the cast image. (This explains why the reverse phenomenon is not the opposite of animation: we expect, and in fact often find, that these images made from life retain the feeling of life and suggest an animate presence.) This difference between casts and other images is reflected in our divergent responses to photographs and paintings. The photograph is like a cast in the realm of two-dimensional images.

This difference explains why the reverse phenomenon is rare in painting and comparatively frequent in photography. If a painted portrait is already simply an image, if it already lacks real animation, depicting the person as turning into a lifeless image can only remind us of the fact that it *is* a lifeless image. This reminder would not be welcome in a painting that strives for illusion. The difficulty in painting is to make the image seem alive. Photography, though, has a different starting point. Because it provides a direct record of an animate being, it can be a triumph of photographic art to make us see that person in a new way.

(The fascination with people becoming representations is also found in the entertainments of tableaux vivants and living sculptures, in which actors pose to re-create paintings or imitate sculptures. These provide an ironic twist, for we marvel at the actors' likeness to representations that are themselves attempted likenesses of human models—representations that often garner praise for their ability to create the illusion of human presence.)

Photography not only allows us to see people in new ways, it can transform the way we see representations. It carries on painting's interest in the ambiguous presentation of paintings and sculptures, but with unprecedented force and breadth.

One might think a painter, limited only by his or her skill and imagination, has the greatest opportunity to create ambiguity. And true, the painter can make a sculpture or painting as lifelike as the human figures he or she paints, but this is done at the risk of having the image identified as of a human being rather than as of an animated painting or sculpture. The painter must therefore take pains to somehow distinguish the represented painting as a painting or the represented sculpture as a sculpture, if it is to be read as such. A photographer, on the other hand, can strive to equate painting and person without fear that the two will actually become indistinguishable, for if the subject photographed is a painting, it remains literally a painting no matter how dynamically it is photographed. This creates the opportunity for rich ambiguity, both perceptual and gestural.

Perceptual ambiguity in photographs results partly from the nature of the medium itself. The stillness, the flatness, and, in black-and-white photographs, the limitation to monochrome values, all contribute to masking the differences between people and representations. This masking can be aided by a careful choice of angle, framing, and lighting. Gestural ambiguity can be achieved by juxtaposing a representation with events or people in such a way that the representation appears to be responding to its surroundings. Again, the shrewd selection of angle or light can enhance the representation's expressiveness. And just by selecting a representation as subject matter, the photographer focuses our attention on it as though on a real person, encouraging our tendency to anthropomorphize.

Photographic ambiguity can be created by both perceptual and gestural means, but how does it function? Like the Renaissance ambiguity that animates, or like the ambiguity found after Impressionism which tends to under-

cut the status of the "real" things depicted? The function of ambiguity in photography cannot be defined so narrowly, but at least in one respect, it resembles its Renaissance counterpart. Photographic ambiguity tends to animate representations rather than undermine pictorial illusion. When in a photograph, a person is made to seem equivalent to a picture or a statue, we are not thereby encouraged to see the photograph as mere image, or the entities it presents as mere traces of emulsion on paper. The equivalence created may be surreal, humorous, or uncanny, but it does not puncture our belief in the person's animate reality or in the statue's independent existence. Whereas the pictorial illusions of painting can be subverted by this sort of equivalence, the apparent realism of photography remains undiminished. (This will be explored in the next chapter.)

Photography's success in achieving ambiguities and equivalences is so startling and compelling that it is no surprise that we find such ambiguities employed again and again throughout the history of photography. From the early photographs of Daguerre, Nègre, and Bayard, through those of Atget, Cartier-Bresson, Kertész, and Evans, to the photographs of more contemporary artists like Robert Mapplethorpe, David Levinthal, and Laurie Simmons, we find images of mannequins, sculptures, dolls, paintings, and billboards. Representations of all sorts figure prominently in a vast array of photographs from all periods and many traditions—commercial, journalistic, as well as fine art. And many of these photographs play more or less explicitly with the idea of animation, with the confusion between representation and real thing that photography can encourage, with the seeming transformation of a representation into a living being. Whereas the painter can create an image that will be ambiguous, the pho-

tographer can take an already existing sculpture or picture and make it ambiguous to our eyes, transforming the objects and images around us. The store window mannequin, the graveyard statue, the roadside billboard can all come to life through the camera. Through photography, the desire of Pygmalion and the dream of Coppelius are fulfilled.

Transformation
in Photography

Why does photography require a separate discussion? After all, in the analysis of the preceding chapter, no distinction was made in the way ambiguity appears in the different media of drawing and painting, watercolor and oil, manuscript illumination and fresco. No distinction was needed, for though these media differ in their techniques and visual effects, their images all originate in human gesture, as traces of such gesture. The photographic image, however, insofar as it is mechanically produced, is not tied in quite the same way to intention and gesture. As a result, ambiguity in photography can take on a distinctive character.

The Special Character of Photography

In the early days of photography, Louis Daguerre proclaimed the revolutionary nature of his invention by declaring: "The daguerreotype is not merely an instrument which serves to draw nature . . . [it] gives her the power to reproduce herself." A century later, Roland Barthes echoed this sentiment, describing the photograph as "literally an emanation of the referent."[1] Daguerre and Barthes are but two of the many photographers and writers who have supported the idea that there is a special connection between photographs and the objects they present, one that distinguishes photography from the other pictorial arts.

Rudolf Arnheim describes this special connection in his essay "On the Nature of Photography." According to Arnheim, when a photograph is taken "the physical objects themselves print their image by means of the optical and chemical action of light" and this gives photographs "an authenticity from which painting is barred by birth."[2] Photography's special significance lies in its documentary quality, in the fact that the photographer does not have the painter's freedom to create and control.

But if this is true, we can only evaluate photographs as documents, as more or less true to the world. We cannot evaluate them as art because we cannot see them as the product of creative activity. At least this is what Joel Snyder and Neil Walsh Allen claim follows from Arnheim's view. In their article, "Photography, Vision, and Representation," they defend photography's art status by arguing against Arnheim's claim that photographs directly record reality.[3] They deny that the photograph can be treated as a reliable index of what was in front of the camera by describing the many ways in which the photographic image diverges from what we see when we look at the world. These divergences mean that there

is no one "true" picture of what is photographed, only various ways of presenting the subject. The photographer's choice of shutter speed, lens, and camera angle will determine the look of the resulting image. It is because the photographer has this choice and control that we can evaluate photographs as art.

Snyder and Allen persuasively demonstrate the creative role of the photographer and the consequent artistic significance of the photograph, but their argument does not rest here. They not only claim that we can evaluate photographs as art, they also claim that we can evaluate photographs in much the same way that we do paintings. In support of this contention, they note that photography has borrowed from and built upon the conventions of other arts, notably painting. Since, on their view, there are no unique conditions governing the use of these conventions by photographs (since there is no special connection with reality to take into account), photography needs no special critical principles, no special analysis, of its own.

This denial of special critical principles, however, makes it impossible to fully account for the ways in which we actually experience and evaluate photographs. In what follows, I argue that we do experience photographs differently from paintings and that the critical demands of the two media diverge. I explain this divergence not by showing that photography is actually more closely tied to reality than painting, but by showing that we *perceive* it in this way. Whether it is warranted or not, we tend to see photographs as objective records of the world, and this tendency has a far-reaching influence on interpretation and evaluation.

My analysis of the way we experience photographs thus does not depend on resolving the dispute between those who see the photograph as a mechanical record and those who stress the photograph's deviance and the photographer's creative control. It does, however, make use of insights from both sides of the

dispute. Although the photograph may be *understood*, at least in part, as a construction of the photographer, and as itself transformative of the objects it presents,[4] it may nevertheless irresistibly be *seen* as presenting us with a record of fact.[5] In this chapter, I show how an attention to both of these aspects of the photograph is essential to the understanding of photographs of representations, and to understanding the ambiguity they often display.

Eugène Atget, André Kertész, Henri Cartier-Bresson, and Walker Evans are but a few of the many photographers who have taken representations, such as paintings, billboards, signs, photographs, sculptures, and mannequins, as their subject. In many of their photographs, a transformation of the photographed representation occurs—a sculpted figure is seen as animate, a pictured space is seen as a real space. Representations and real things can be made to seem equivalent.

This phenomenon is not just a feature of "art" photographs; it will be familiar to anyone who has seen gag photographs of people posing with cutouts of celebrities, or souvenir photographs in which people position their heads over the plywood bodies of bathing beauties and body builders. These gag photographs can sometimes be quite effective because the cutouts look more "real" in the photograph than in person. This phenomenon also accounts for the popularity of painted backdrops of various sorts in nineteenth-century and early-twentieth-century portraits. In a photograph, the backdrop could be fairly successful in creating the illusion of space.

I will show that these phenomena of transformation depend on the photograph's divergence from reality. Nevertheless, I will argue that the power and fascination of photographic transformation depend on the fact that we irresistibly see photographs as presenting us with a record of reality. By showing that, unlike painting, we read photographs as documenting the world, I will be

showing that photography cannot simply adopt painting's critical principles. Photography demands a separate analysis.

Photographs of Pictures

Walker Evans's *Torn Movie Poster* (1930) shows us a fragment of a poster on which is depicted the faces of a man and a woman. These faces are themselves fragments—they are cropped by the edges of the photograph, by the border of the poster, and by a tear in the poster. The tear starts at the upper right-hand corner, where it reveals a wall with the fragments of a dark poster clinging to it. It cascades downward, cutting into the woman's brow and continuing in a jagged vertical line along her cheek; the black of the underlying poster divides her face. The effect of this image is disturbing and grotesque. We read the photographed picture of a woman as a photographed woman; we read the torn picture as a torn woman.

While no one would actually *believe* that the photograph of the poster is the photograph of a real woman, we nevertheless respond to it in much the same way that we would respond to the photograph of a woman.

The torn poster is not in itself grotesque: we would probably not find it arresting or disturbing if we were to see it in person. This is because we normally see torn and fragmented posters, signs, and magazine covers for what they are—torn pictures. It is only when these torn pictures appear in photographs that they have the power to disturb us, for in photographs they no longer appear as mere pictures. The grotesque effect of the photograph of the movie poster depends on the equivalence of object and its representation, of woman and picture-woman, that photography allows.

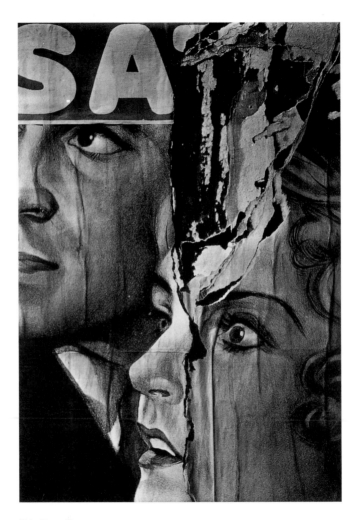

Walker Evans

Torn Movie Poster, 1930. Gelatin-silver print, $6^3/8 \times 4^3/8$". Collection, The Museum of Modern Art, New York. Purchase. © Walker Evans Archive, The Metropolitan Museum of Art.

This equivalence between photographed object and photographed picture of an object is achieved primarily through the photograph's flatness. Painted images of objects are flat. By contrast, the objects that serve as models for those paintings are three-dimensional—objects and their pictures inhabit different types of space. But in a photograph, pictures are *reproduced* in their two-dimensionality, whereas objects are *reduced* to two dimensionality. In this way, the object and its picture are put on the same footing, they cannot be distinguished by the type of space they occupy.

So the Evans photograph is grotesque at least in part because the two-dimensionality of the photograph allows us to read the torn picture as a torn woman. This grotesque effect is enhanced by the cropping, which forces us to focus on the expression of the woman's face. Her partially open mouth and staring eyes give us the sense that she is startled and somewhat fearful. Her expression encourages us to see the photograph as disturbing and to see, in her apparent disintegration, cause for her horror.

But this does not yet fully explain the photograph's disturbing nature. We see the woman as torn, but we also see the wall coming through—asserting the fact that, after all, what we see is a photograph of a poster peeling off a wall. The person is shown to be just a picture. This realization is aided by the creases of the face, caused by the inexpert pasting of the poster to the wall. The photograph leads to a double vision: we know we are looking at a photograph of a poster, but we see it as a photograph of a woman. The tension between the two incompatible ways of seeing the picture is disturbing and surreal in that it seems to represent the horrible and impossible—the person made object, the person breaking apart to reveal a wall.

The photograph thus presents us with a string of transformations. A three-

dimensional entity, a person, is reduced to two dimensions through depiction in the poster. Through photography, the represented woman is restored to the status of a three-dimensional entity. But she is partially (and only partially) divested of that status by the disintegration of the representation and the intrusion of the wall.

Similar transformations can be found in Evans's *Furniture Store Sign near Birmingham, Alabama* (1936), only what is brought to "life" in this photograph is not a picture-woman but the picture-space of a roadside billboard. Unlike *Torn Movie Poster, Furniture Store Sign* presents a billboard that is neither disintegrating nor incomplete. We see the entire sign, wholly intact and placed within its surroundings. The right-hand side of the billboard depicts, in crude perspective, a room in which three somewhat translucent children play on a Congoleum rug, while two equally translucent women sit on a sofa, looking on. The left-hand side of the billboard depicts a landscape with a brook and trees; the text of the advertisement appears in the sky. In the photograph, the billboard does not read as a flat object blocking the view of houses. Instead, the landscape and the room it pictures seem to open up a three-dimensional space. This illusion is undercut in several ways. The partition of the sign into two discontinuous parts, the presence of the text in the sky, and the translucency, irregularity, and primitive nature of the picture all serve to reassert the room's picture status. Again, this last *partial* transformation leads to a double vision.

The confusion of the status of the billboard in *Furniture Store Sign* is intensified by the apparent intermingling of real and represented space: the texture of the ground depicted in the painted landscape seems almost continuous with the real ground on which the billboard rests.

This intermingling and resultant confusion of real and represented space is

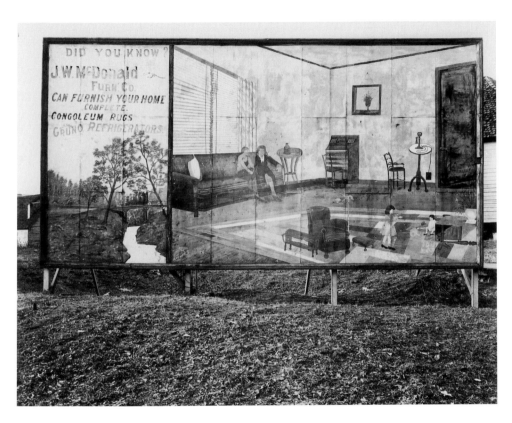

Walker Evans

Furniture Store Sign near Birmingham, Alabama, 1936. Photograph.
Library of Congress, Washington, D.C.

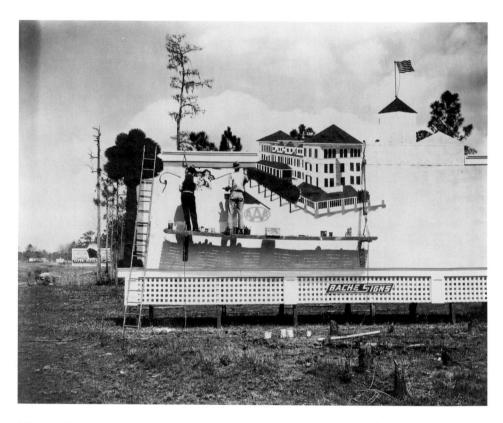

Walker Evans

Billboard Painters, Florida, c. 1934. Gelatin-silver print, 7 1/4 × 8 3/4". Collection, The Museum of Modern Art, New York. David H. McAlpin Fund. © Walker Evans Archive, The Metropolitan Museum of Art.

even more pronounced in *Billboard Painters, Florida* (c. 1934). In this photograph two men stand on a scaffold as they paint an irregularly shaped billboard. The irregular shape of the billboard allows the painted tree, roofs, and flag to poke into real space and to stand out against the real sky. At the same time, the white of the sky is continuous with the white of the unfinished billboard; it invades the picture space. The irregular shape of the billboard and the continuity of the white of the sky with the white of the billboard's ground create a confusion of real and represented space that allows the painters to be almost absorbed into the picture world they are creating.

Minstrel Showbill, Alabama (1936) also shows a striking intermingling and interpenetration of real and represented space, but the real space in this case is the brick wall revealed by the deterioration of the showbill. Like *Torn Movie Poster*, the showbill's image is cropped and disintegrating, and the disintegration can be seen as contributing to the alarm of the people pictured. Viewers, however, are less likely to be disturbed by the showbill's deterioration than by its racial content. The showbill makes use of racial caricatures in depicting a scene of chaos and confusion: people running and falling, a young man trying to escape with a watermelon, a dog biting, a mule kicking, a washtub overturned. This confusion is increased by the disintegration and consequent incompleteness and discontinuity of the image.

The increased confusion is not just the result of a fragmented image, though. It also arises from the crazy intermingling of brick wall and showbill image, the solid immutability of the wall invading the chaos of the pictured scene. The photograph shows an intersection or clash between two worlds, two spaces. Unlike *Torn Movie Poster*, where the wall is definitely underneath the pictured woman, the spatial relation between wall and pictured scene in *Minstrel Showbill* is more

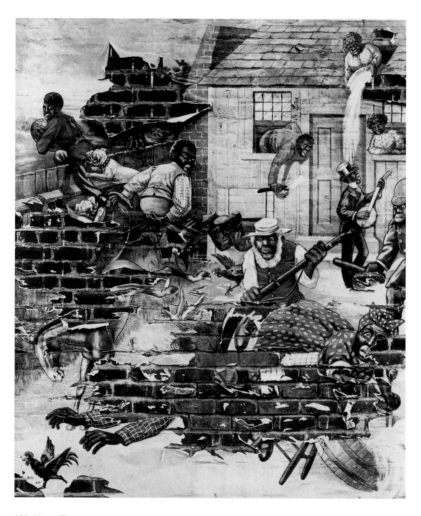

Walker Evans

Minstrel Showbill, Alabama, 1936. Gelatin-silver print, $7^1/2 \times 6^9/32$".
The J. Paul Getty Museum, Los Angeles.

ambiguous and reversible. Now we see the wall coming through the poster, now we see the scene as if through breaks in the wall. This ambiguity arises because, although the wall is seen as underneath the poster, it exists in a very shallow space; the depth of the pictured scene, on the other hand, is much greater. Our gaze is pulled back by the scene and forward by the wall. The relation between the picture and the brick wall is even further complicated by the existence of a brick chimney in the pictured scene, which pulls a segment of the picture to the plane of the wall.

The effect of a "clash between two worlds" can also be found in photographs of reflections in glass, water, and mirrors. For instance, in Evans's *Street Scene, Brooklyn* (c. 1931) a dresser standing on a sidewalk reflects in its mirror a truck bed filled with chairs. We see only the top of the dresser with its mirror, behind which stands a large crate, a brick wall, and the door of a building. The mirror seems to open up a hole in the crate and the building, to show discontinuous spaces intersecting. The effect is one of spatial collage, but a collage that has been found, not constructed.

Henri Cartier-Bresson's *Seville* (1933) is reminiscent of *Minstrel Showbill* and *Street Scene, Brooklyn* in the way it creats an intersection and fragmentation of spaces. But in this case, the fragmentation results not from the juxtaposition of pictorial or reflected space with actual space, but from the juxtaposition of a deep space and a flat wall parallel to the plane of the photograph. Through a gaping hole in a wall we see boys playing in the ruins of some buildings. Other boys stand in front of the wall, close to the camera. The flatness of the photograph, the jagged framing of the foreground wall, and the white neutrality of that wall, make the space in which the boys play appear to be a torn fragment of the world

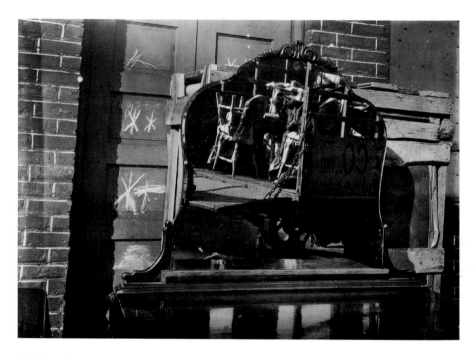

Walker Evans

Street Scene, Brooklyn, c. 1931. Gelatin-silver print, 4³/₈ × 6¹/₂" (11.1 × 16.5 cm). Courtesy of The Museum of Modern Art, New York. David H. McAlpin Fund. © Walker Evans Archive, The Metropolitan Museum of Art.

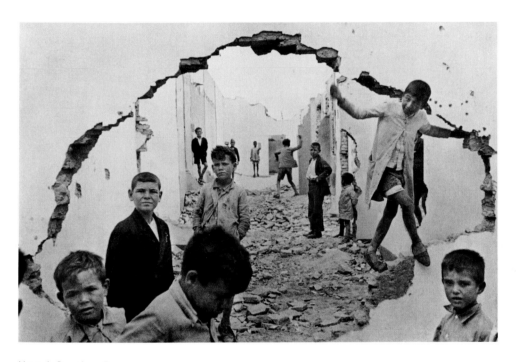

Henri Cartier-Bresson

Seville, 1933. Photograph. © Henri Cartier-Bresson/Magnum Photos, Inc., New York.

surrounded by white emptiness. One boy steps across the wall and thereby seems to be bridging the two incommensurable spaces.

Conditions of Transformation

> One of the perennial successes of photography has been its strategy of turning living beings into things, things into living beings. **Susan Sontag,** *On Photography*

It is not just pictorial representations that are transformed by photography; Galatea-like transformations can be found in photographs of sculptures, dolls, and mannequins. In Evans's *Courtyard, Havana* (1932), a broken, partially clad, jockey hitching post stands framed by the pipes and the crumbling, stained wall of a bleak courtyard. The jockey's painted eyes stare blankly into the distance, his mouth a grimace. His outstretched arm is broken at the wrist, his other is broken at the shoulder.

Like *Torn Movie Poster*, the photograph has an unsettling effect, because we tend to read the broken statue as a mutilated person. Here, too, the grotesque effect depends on the fact that we are looking at a photograph of the statue; if we saw the statue in person it would not have so powerfully disturbing an impact. For instance, the missing limbs and broken noses of the ancient statues we see in museums do not normally impress us as grotesque, and disembodied sculpted heads do not usually strike us as gruesome. Photographs, by making statues seem alive, make damage and incompleteness macabre. (In *Courtyard, Havana* this process is aided by the painted clothing and grim surroundings of the statue.)

Walker Evans

Courtyard, Havana, 1932. Photograph. © Walker Evans Archive, The Metropolitan Museum of Art.

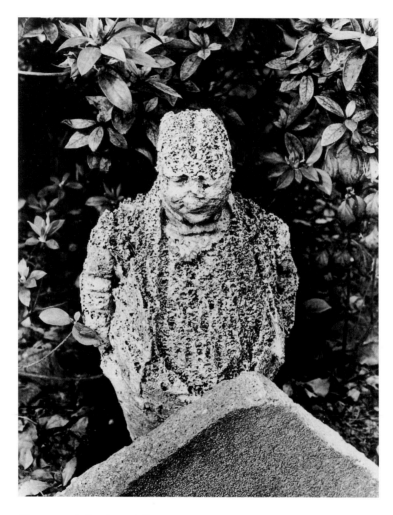

Clarence John Laughlin

Our Festering Hands Ruin All . . . , 1951. Photograph. Courtesy The Historic
New Orleans Collection, accession no. 1981.247.1.805.

Clarence John Laughlin's *Our Festering Hands Ruin All . . .* (1951), also presents us with an image of the macabre. The stucco garden statue in this photograph is so decayed that only a portion of its face is visible; yet this is enough to animate the figure and to make us see in its decay something horrible and distressing. In person the decaying figure would be seen for what it is, deteriorating plaster. In the photograph, the figure is seen as grotesquely human.[6]

Unlike the previous examples, the sculpture in Evans's *Gravestone, Louisiana* (1935) is neither damaged nor decayed. The photograph shows a young man and his dog gazing at the viewer from their station atop a tomb. These figures are obviously of the same stone as the tomb, but their forms are strangely animate. Here, the eerie character of the animation is intensified by the fact that the sculpture is a gravestone. The soul of the dead man seems to have taken up new residence in the representation perched upon his tomb.

As with the photographs of pictures, the disturbing effect of these photographs of statues seems to arise from the creation of an equivalence of status between sculpture and person, but the reason for this photographic equivalence is not so obvious. Whereas the flatness of pictures is "overcome" by photography in that the whole world is made two-dimensional, the three-dimensionality of sculpture matches the three-dimensionality of people. Why should an equivalence of sculpture and person be more pronounced in the photograph, where both are made flat? The answer to this question will not only help us understand the animation of sculptures, it will also provide us with a more complete understanding of the animation of pictures. For both pictures and sculpture, equivalence—and hence animation—is encouraged by the photograph's motionlessness, its lack of color, and by our tendency to anthropomorphize objects selected for our attention by the photograph.[7]

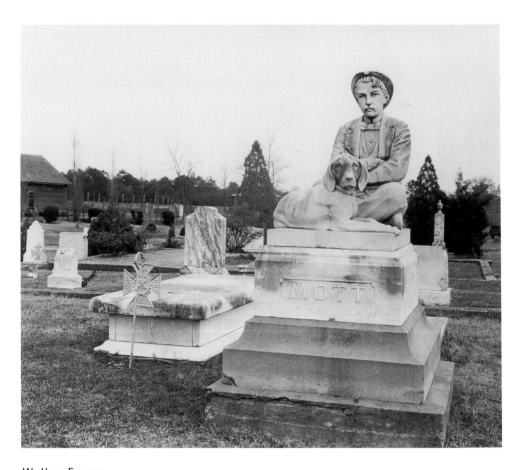

Walker Evans

Gravestone, Louisiana, 1935. Photograph. Library of Congress, Washington, D.C.

In real life, representations impress us as inanimate. They generally are stationary in a world where living things move. The still photograph minimizes this distinction between the animate and inanimate. Both people and things are presented without motion. And even when motion is suggested, an equivalence between animate and inanimate can be created. Cartier-Bresson's *Behind the Gare St. Lazare* (1932) freezes a man in mid-leap, allowing his position to be echoed by that of the figures pictured in the posters behind him (see p. 109). The real movement is matched by the fictional movements, and this matching is made possible by the fact that the photograph suggests motion in the same way that drawings and paintings do.

One might expect "moving pictures," film, to destroy this source of equivalence. But even film has techniques at its disposal to preserve the equal footing. Using representations that move, such as marionettes, puppets, or mechanical figures, is one such technique; creating suggestive juxtapositions of representations with motionless people is another. But perhaps the most striking technique at film's disposal is the inclusion of a film within the film, a strategy that can provide great opportunities for equivalence and ambiguity. The action of a film within a film can have a presence equal to or even greater than that of its containing film, especially when the scale of the embedded film and its prominence within the frame dwarfs the action that may surround it. The result of such juxtapositions can be quite poignant and powerful, as in the last scene of Augusto Genina's *Prix de Beauté* and as in the Radio City Music Hall sequence of Alfred Hitchcock's *Saboteur*. (These and other examples are discussed in greater detail in the next chapter.)

The use of black and white also promotes the animation of representations in both film and still photography. A black-and-white photograph conceals devia-

tions from natural coloring in statues and in pictures; it conceals color distinctions among paint, marble, and flesh. Furthermore, the unnatural world of black and white facilitates our perception of unnatural "magical" animation. The farther removed the depicted world is from our natural world, the less we expect conformity with natural law. Color photographs are less prone to animation not only because they preserve the natural color differences between animate and inanimate materials and and not only because they raise expectations of naturalism, but also because they tend to appear less flat than black-and-white photographs, thus undermining an important condition of animation.

Nevertheless, some color photographs do succeed of animation. Kaz Tsuruta's photographs for the exhibition catalogue *New Look to Now: French Haute Couture, 1947–1987* provide an interesting case in point.[8] The catalogue is illustrated with black-and-white *and* color photographs of mannequins wearing the various designs. Most of the color photographs do provide examples of animation, but there are several factors that contribute to this effect. First of all, the lifelike poses of the mannequins facilitate the animation, as does the occasional concealment of the sightless white eyes by sunglasses or mask, by averted head or turned back. Secondly, in almost all of these photographs, there is very little (if any) real space visible. The mannequins stand before paintings, tapestries, curtains, and carpets that fill the background, or they stand in a neutral "empty" space. This serves to minimize any contrast between real and artificial, between animate and inanimate. Furthermore, there are no people in these photographs with whom the colorless mannequins can be compared. Instead, the mannequins are shown with other representations: paintings and sculptures.

This juxtaposition with paintings and sculptures leads to some interesting effects. In one photograph, *Dinner Dress, Christian Dior, Winter 1956* (1989), the

Kaz Tsuruta

Dinner Dress, Christian Dior, Winter 1956, 1989. Photograph (original in color). © Kaz Tsuruta.

mannequin stands in front of a painting of a muse looking out at the viewer from behind a curtain. Not only is the muse naturalistically colored, but her eyes and smile engage the viewer. As a result, the painted muse appears fairly animate, all the more so because she can be contrasted with the unnaturally white, sightless mannequin. Nevertheless, the muse does not derive *all* the benefits from the comparison; the mannequin emphasizes, by its three-dimensionality, the flatness of the painting and of its flirtatious subject.

The mannequins and pictures in Tsuruta's color photographs are animated through artful poses and creative juxtapositions; but one need only look at his black-and-white photographs to see more dramatic effects, to see cold hard plastic change into flesh. Although animation is certainly possible in color photography, it is facilitated and enhanced by the use of black and white.

Finally, the animation of representations is aided by our tendency to anthropomorphize those objects selected for attention in a photograph. This tendency is particularly strong when the object displays human features, especially when those features are expressive. This expressiveness can be enhanced by camera angle, lighting, and the prominence of the features within the photographic composition.[9] It can also be greatly enhanced by context.

The importance of size and expressiveness of features can be seen in Charles Nègre's *Gargoyle of Notre Dame* (1851), in which the gargoyle seems more alive, more animate, than his human companion, Henri Le Secq. The gargoyle's features are large and visible; they overpower the smaller, shadow-obscured features of Le Secq and convey more forcefully a sense of life.

A similar effect can be found in a much more recent photograph, Rosalind Solomon's striking *Kali's Demons*, Calcutta, 1981. In this photograph, the realistic and intense expression of the figure on the right overshadows the more sub-

Charles Nègre

The Gargoyle of Notre Dame, 1851 negative, reprint 1960s. Photograph.
The Metropolitan Museum of Art, Rogers Fund, 1962. (62.604.1).

Rosalind Solomon

Kali's Demons, Calcutta, 1981. Photograph. © 1981 Rosalind Solomon.

dued features of the small child. (The child's face is literally overshadowed by the figure's hand.) In this case, however, there is a grotesque side to the image, to the conjunction of the realistically animate face with the coarsely malformed body.

A more humorous example of the way in which expression and context aid animation is found in Cartier-Bresson's photograph of André Pieyre de Mandiargues (1933). In this photograph, Mandiargues stands smoking under a large billboard advertising cheese; he is placed directly beneath the huge noses of three heads huddled together on the sign. As with the Nègre photograph, there is an amusing contrast between the large, grotesquely expressive features of the billboard caricatures, and the smaller, impassive, or at least more concentrated, features of Mandiargues. But the fact that the men on the sign seem to be responding to a pungent smell, one whose source appears to be a real object, the cigarette puffed by Mandiargues, makes the attribution of animation to the three men even harder to resist.

Another Cartier-Bresson photograph, *Texas, 1947*, also shows the importance of expression and context. It shows a man leaning with his elbows on a pinball machine. To his right is a large Coca Cola advertisement, featuring a smiling woman. To his left is the pinball machine display. The animation of the woman in the advertisement is aided by the fact that she appears to be roughly the same size as the man, and she is positioned in such a way that she seems to be looking over his shoulder. Not only is she gazing in the same direction that he is, her smile also echoes his. The two are further brought together by the two bits of text that appear in the photograph. The word "refreshing," which appears above the woman to her right, and the word "special," which appears above the man to his left, bracket the couple.

Henri Cartier-Bresson

André Pieyre de Mandiargues, 1933. Photograph.
© Henri Cartier-Bresson / Magnum Photos, Inc., New York.

Henri Cartier-Bresson

Texas, 1947. Photograph. © Henri Cartier-Bresson / Magnum Photos, Inc., New York.

The Ringl and Pit advertisement for Petrole Hahn (1931) points up the importance of context in a very different manner. The photograph shows a mannequin holding a bottle. We only see the mannequin's head and robed shoulders; the hand, though artificially posed, is real. We cannot reconcile these incongruous elements. The mannequin's head with its sweetly vacuous expression makes us look differently at the hand: we want to see it as belonging to the mannequin; and the real hand makes us look differently at the head: we want to see it as real. This incongruity results in an unsettling and somewhat freakish tug of war between animation and its reverse.

Petrole Hahn shows how context can be important not only to animation but also to the achievement of the reverse phenomenon, the apparent transformation of a person (or part thereof) into a representation. Arnold Newman's 1942 photograph of George Grosz provides another striking example of this phenomenon. In this portrait, Newman places Grosz's head among a diverse collection of sculptural fragments: an ear, the back of a female torso, a mannequin head, and a small-scale male anatomical figure. It is with surprise that we first discover Grosz's head in the lower right-hand corner. Cropped at the neck, his head has also become a "sculptural fragment." This effect is enhanced by the fact that his eyes do not engage the viewer. They gaze off "blankly" into the distance, like the eyes of the mannequin above him.

This "reverse phenomenon" is also achieved by Helen Levitt, although through quite different means. In *New York, c. 1942*, two boys support a large mirror frame on a busy city sidewalk and a third boy on a tricycle is framed within it. He becomes a reflection, even though the hands of the boys can be seen grasping the inside of the mirrorless frame, and even though the boy on the tricycle does not "mirror" the figures in front of the frame.

Ringl and Pit (Ellen Auerbach and Grete Stern)

Untitled (Petrole Hahn), 1931. Photograph. © Ringl + Pit.
Courtesy Robert Mann Gallery.

Arnold Newman

George Grosz, 1942. Photograph. © Arnold Newman.

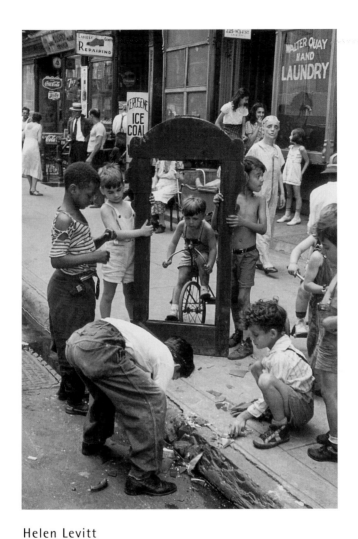

Helen Levitt

New York, c. 1942. Photograph. © Helen Levitt.
Courtesy Laurence Miller Gallery, New York.

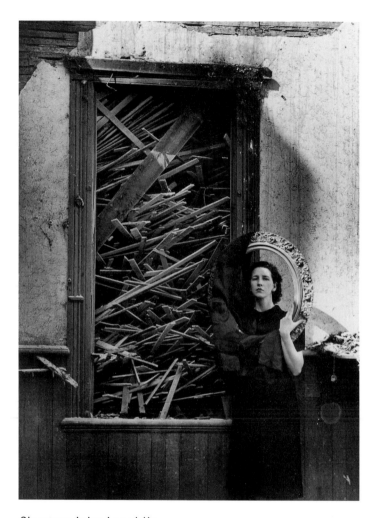

Clarence John Laughlin

The Ego-Centrics, 1940. Photograph. Courtesy The Historic New Orleans
Collection, accession no. 1981.247.1.745.

A similar, though more contrived, transformation occurs in Clarence John Laughlin's *Ego-Centrics* (1940), in which a woman looks at us through an elaborately carved oval painting frame that she holds. Although her left arm is visible, the right one is hidden by a cloth draped over one side of the frame. She partially "becomes" a portrait. Behind her is a large glassless window, through which we see a jumbled mass of scrap wood, completely filling the opening of the window's frame. The image is oddly disturbing, for the window frame tends to pictorialize the scene, but the wood mass, instead of receding as a picture space, appears ready to burst through the frame.

The examples discussed here show a variety of ways in which features such as flatness, the absence of color, the absence of motion, and expressiveness can be exploited by photographs to encourage animation (or its reverse). Although none of these features is a necessary condition (for instance, some color photographs can animate), each enhances the opportunities for animation. And although none of these features is sufficient, attention to each helps us to understand why some photographs of representations are more animate than others.

Painting, Photography, and Reality

It has not yet been shown that the animation I have been discussing is a peculiarly photographic phenomenon. After all, paintings are also flat and motionless, and they, too, can dispense with naturalistic color. In fact, we have already seen that painting, as well as photography, can transform its subjects and create equivalences between people, objects, and their representations. Nevertheless, I will argue that the transformation and equivalence found in painting differs in

an important respect from that achieved by photography. Because we readily think of paintings as constructions, we see the equivalences and transformations they show as products of the artist's imagination. On the other hand, because we tend to think of photographs as objective records of the world, the phenomena they show, no matter how surprising or disturbing, are not as easily dismissed as imaginative fictions.

Consider again the two paintings by Magritte previously discussed. In *The Human Condition*, a painting is depicted as being as "real" as the landscape that serves as its model; in *Attempting the Impossible*, the artist and the figure he paints are depicted as sharing the same space and as possessing equivalent status. In both paintings, Magritte erases the distinction between representations and the three-dimensional world represented; but in erasing this distinction, he dispels any illusion that what we are looking at corresponds to reality.

In Magritte's paintings there is a tension between illusion and its self-subversion. The paintings represent a world, but at the same time they assert their status as fabrications and their freedom from the task of representing the *real* world. They make this assertion not only by self-reflexively calling attention to their own status as mere images, as in *This Is Not a Pipe*, but also by depicting the impossible or fantastic.[10]

Of particular interest here is Magritte's *The End of Contemplation*. The painting shows a head in profile that is torn, as if made of paper. Not only are we shown an impossible object—a paper head—but that object's status as mere image is emphasized by the way in which the jagged tear of the head echoes the jagged tear of the background, by the doubling of the image, and by the attachment of twelve metal snap fasteners to the painting's surface. Although provocative and disconcerting, *The End of Contemplation* is not as forcefully disturbing

René Magritte

The End of Contemplation, 1927. Oil on canvas with metal snap fasteners, 28⁵/₈ × 39³/₈" (72.8 × 99.8 cm). The Menil Collection, Houston. © 1999 C. Herscovici, Brussels / Artists Rights Society (ARS), New York.

as *Torn Movie Poster*, and this difference in effect can be explained by a difference in how we perceive paintings and photographs.

Rightly or wrongly, a photograph is thought of as having a closer connection to the objects and events it depicts than even the most documentary painting. Because of the mechanical nature of its production, the photograph seems to have a special connection with reality and an independence of the photographer's intentions. For example, if there is a horse in a photograph, we assume that there must have been a horse in front of the camera, since the horse cannot just be a product of the photographer's imagination. For this reason, a photograph is thought to verify the existence of its subject in a way a painting never could; the photograph requires the presence of a horse for its production, while a painting could depend wholly on the artist's imagination.

This perceived special connection of the photograph to its subject accounts for our different responses to paintings and photographs and for the different ways in which we use them. Kendall Walton observes in "Transparent Pictures: On the Nature of Photographic Realism" that photographs are more readily accepted as legal evidence than paintings or drawings, that they are more effective as tools of extortion, and that they present the horrors of war to us with greater immediacy.[11] For example, a painting or drawing of the carnage of a battlefield, no matter how graphic, does not compel and disturb us in quite the same way that a photograph of the same subject does.[12] In the photograph, we seem to actually see the dead bodies, and it is hard for us to attribute the chilling and convincing nature of the image to the excesses or complicity of the photographer.

Whereas Walton uses these observations to provide evidence that photographs are "transparent,"[13] I will use them to support the claim that photographs are perceived to possess an objectivity unavailable to painting.[14] For instance, we

think of the corpse-strewn battlefield as directly, mechanically documented by the camera. The photograph is thus thought to provide us with an authoritative record. The painting of the battlefield, however, is perceived otherwise, for we are aware of the subjectivity of the process and the license of the painter. The painting is thus thought to be, at best, an artist's rendering of the scene, and at worst, a complete fabrication.[15]

Our awareness of the license of the painter, of his or her freedom in depicting the world, is increased when the event being depicted is seen as impossible or unnatural. For this reason, Magritte's paintings are quite readily seen as illustrating fantasies of the artist's imagination. The illusion that these paintings correspond to real events is subverted by the very unnaturalness of the events. We know that the transformations, equivalences, and ambiguities shown are most certainly the creation of the artist and we have no tendency to see the paintings as records of an ambiguous or unnatural reality. This would be true even if the paintings were done in a more realistic style. The point is that as long as the works are identified as paintings, they will be seen as products of the artist's imagination, to the extent that what they depict does not conform to what we know of the world. When, on the other hand, works are identified as photographs, they are seen not as products of the imagination, but as records of our world. This explains why photographs can have a peculiar unsettling power and fascination. The disturbing images in photographs are seen as corresponding to a disturbing reality; they are not so easily dismissed as mere fantasy.

It is instructive to see what happens when, for example, Magritte's paintings are photographically reproduced. From the foregoing discussion of photographs of representations, we might expect the photographed paintings to be transformed, the painted figures to take on a full-bodied reality. But to the contrary,

such a transformation does not occur; we do not see the world of the painting become part of the non-representational "real" world displayed by photographs.

The photographs discussed earlier in this chapter suggested animation by showing us representations situated within the world. An art reproduction, however, especially one of a painting, generally eliminates such context because a reproduction is typically used as a copy or substitute for the work of art. The painting is not seen as an object within the photograph, it is seen as the image presented by the photograph. The intrusion of the world surrounding the work of art, however, or the work's own disintegration, introduces elements that can defeat a reading of a photograph as an art reproduction and enable the animation of the pictured work.

Torn Movie Poster is not read as an art reproduction at least in part because the cropping of the image and the prominence of the tear do not conform to the conventions of reproduction. We do not see the photograph as simply a document of an independently existing work. Furthermore, the tear, the texture of the wall, and the creases lend a physical substance to the poster image: they alert us to the fact that we are looking at a bit of the world, not an insubstantial image. The intrusion of the world into the poster, instead of showing up the poster as a mere representation, imparts its own concreteness to the poster's image. The surface texture and the tear, far from working against animation, allow us to see the picture woman as a real woman.

This explains why Magritte's paintings are generally not animated by photographic reproduction. When photographs of paintings do not display the intrusions of reality or the inflected surfaces that would make the images appear concrete, the paintings remain paintings, untransformed.[16] (The issues surrounding photographic reproduction are discussed at greater length in Chapter 4.)

Documentation and Distortion

The close connection between what the photograph shows and what exists in the world is what Kendall Walton refers to when he speaks of the "transparency" of the photograph, what André Bazin refers to when he speaks of the "realism" of the photograph, and what Rudolf Arnheim has in mind when he says that the objects in a photograph print their own images "by means of the optical and chemical action of light."[17]

In truth, photographs can be far from objective in how they present a subject; the photographer's choice of camera angle, lighting, and framing all influence the way in which the subject will be seen. Furthermore, the characteristics of the medium itself—its two-dimensionality, the delimitation of its image, the use of black and white—all contribute to a divergence between what we see in a photograph and what we would have seen in person. Nevertheless, our awareness of all these factors does not change the way we see photographs—as having a special connection to reality.

There are actually two separate issues here. As Walton, Bazin, and Arnheim all point out, the documentary power of the photograph has to do with the way photographs are typically made; it does not reside in the exact duplication of appearances. Even a blurred photograph has a documentary value unavailable to a drawing or painting.

In fact, the two concerns of documenting and duplicating can sometimes be at odds with each other. For example, a straight, mid-nineteenth-century landscape photograph could clearly show either the land or the sky, but not both: a wet plate exposed for the vegetation would be overexposed for the clouds. To capture all parts of the scene would require the combination of two negatives.[18] The at-

tempt to duplicate appearances thus required the kind of human intervention that was normally thought to damage the image's documentary status. But despite this actual separability, in our minds the two concerns of documenting and duplicating inevitably become intertwined when we look at photographs, and this entanglement accounts for the especially compelling nature of photographic distortions and transformations. Our faith in the documentary character of the photograph is inappropriately, but irresistibly, transferred to the way things appear within the photograph. In other words, not only do we believe that a photograph of a horse is evidence of the horse's existence, we also believe that it shows us what the horse really looks like.

This faith in the photograph's accurate reproduction of appearances is not wholly misplaced; after all, we have come to rely on photographs for identification on licenses, passports, and numerous other documents. But the photograph has obvious limitations as a means of capturing appearances. Consider the photograph of J. P. Morgan shielding his face from the camera: his hat not only obscures but seemingly obliterates his head. We are unable to lightly shrug off the photograph's distortion since we are so used to accepting photographs as guides to the way things appear. It is not that we believe Morgan's head has really been obliterated, but the photograph makes us see him this way. The photograph seems to reveal something strange and unsettling about the way the world looks, and we are startled to find a gap between what the photograph compels us to see and what we know to be true. People with high fevers may *know* that their hallucinations are not real, but they may *seem* real nonetheless; that is why hallucinations can be so distressing. Similarly, we may *know* that what the photograph seems to show is not real, but we may *see* it as real, and that is what makes the photograph so disturbing.

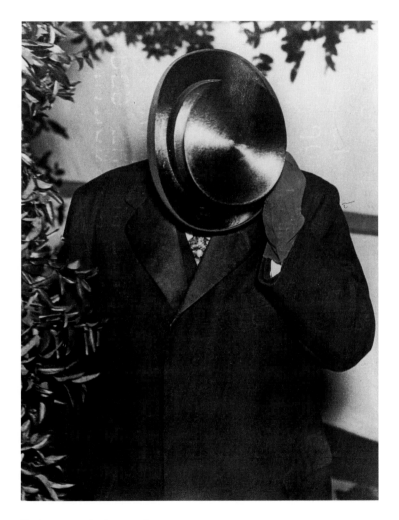

Unknown photographer

J. P. Morgan at Society Wedding Dodging the Camera, 1937. Gelatin-silver print, 20 × 16" (50.8 × 40.6 cm). The Museum of Modern Art, New York. Copy Print © 1998 The Museum of Modern Art, New York.

This way in which we perceive the distortions of photography plays an important role in their aesthetic impact. It explains, for instance, why the ambiguity of Evans's *Billboard Painters* is more compelling than that of Magritte's *Human Condition*. By considering a variety of examples of photographic transformation, and comparing them with corresponding examples from painting, we can better understand this distinctive impact.

In Imogen Cunningham's *Leaf Pattern* (1929), the cropping, lighting, two-dimensionality of the photograph, and the use of black and white lead to the defamiliarization of a very common object, a houseplant. The jagged white areas between the leaves, the strips of leaves in light and leaves in shadow, and the shadows thrown against the wall create a confusion of positive and negative space that is difficult to decipher. The close-up and cropped nature of the image prevents us from getting our bearings, from obtaining a frame of reference. We are shown a houseplant in a way that we never see houseplants in real life.

Paintings also can engage in the defamiliarization of common objects. But the difference between the defamiliarizations of painting and those of photography does not lie just in the materials and processes used. The impact is different. The strangeness of a van Gogh cypress, a Picasso guitar, or a Matisse nude is attributable to artistic license. The artist may choose to simplify forms, to intensify or mute colors, to highlight certain aspects of the objects and to modify others, to analyze an object into its different planes, or to show it simultaneously from different perspectives. The strangeness is seen as resulting from the artist's imaginative rendering and the resulting image is thus seen as diverging from what we would see in real life.

The defamiliarizations of photography are read otherwise, for despite our

Imogen Cunningham

Leaf Pattern, 1929. Photograph by Imogen Cunningham. © 1978 The Imogen Cunningham Trust.

knowledge of the ways in which photographs can mislead and distort, we nevertheless inexorably tend to see them as faithfully recording for us the appearances of the world. So when a photograph defamiliarizes, it is as though something is being revealed to us about our world. Insofar as photography is seen as a means of objective recording, the photographer is not seen as giving us his or her impressions or imaginings, but as showing us the way things really look. So the fascination of *Leaf Pattern* is not just that it shows a houseplant in an unfamiliar or surprising manner; it is that insofar as we see it as a photograph we think of it as an accurate recording, but what it shows us is a houseplant transformed. It may leave us to wonder that a simple houseplant could look so strange.

Even staged photographs can partake in the special kind of defamiliarization characteristic of photographs. Clarence John Laughlin's *Appearance of Anonymous Man* (1949) shows us a woman, her face covered with a cloth and a gnarled piece of wood held out as though it were her hand. The elements that make up the image are readily identifiable; yet the resulting whole is unsettling and eerie. Although we can determine that the figure is just a woman with a cloth covering her face, the cloth seems to have become her face, as though she were an apparition. And although we can determine that the gnarled wood is just something she holds, it seems to have become her hand.

René Magritte has also used cloth-covered faces in several of his paintings, including *The Central Story* and *The Lovers*. Though the imagery is in some respects similar, the response elicited by Magritte's paintings is different from that elicited by Laughlin's photograph. Magritte's images seem mysterious and symbolic, while Laughlin's seems unnatural and unsettling. Magritte's are seen as an artist's peculiar imaginings, while Laughlin's seem to reveal a strange phenomenon of our world.

Magritte is of special interest to us here because he often used photographic studies for his paintings, allowing us to compare closely related images in the two different media. This is true for his painting *The Therapist*. The painting shows a seated man holding a cane, but where the man's torso and head should be there is only a void, a cage with two birds, covered with a cape and hat. The corresponding photograph, *God on the Eighth Day* (1937), accomplishes this effect by showing a man with a painting propped on his lap, hiding his torso and head, the cloak and hat draped over the edges of the painting. Magritte's photographic study is more shocking in its effect than his painting, because the photograph creates the illusion of a missing torso as it records the image of a real person, while the painting only depicts a fiction—a person whose torso is a void.

It is the image's two-dimensionality that allows Magritte's photographic study for *The Therapist* to create the illusion of a missing torso. In person, the two-dimensionality of the painting propped on the man's lap and its placement in front of his torso would be quite evident. Similarly, the two-dimensionality of the image accounts for the illusion of a missing head in the photograph of J. P. Morgan. In the photograph, there does not seem to be enough space in front of the wall for both hat and head. In person, the depth of the space and the position of the hat would be read more accurately.

The photograph's ability to transform its subject through the collapsing of space also plays an important role in Walker Evans's *Gas Station, Reedsville, West Virginia* (1936). The scene presented by Evans's photograph appears quite ordinary: a telephone pole, a sign, a road, a gas station. But the photograph makes of this ordinary scene something exciting. In particular, the lettering on the wall of the gas station and on the public telephone sign seems to jump to life. This can be partly explained by the boldness of the lettering, but not entirely.

Clarence John Laughlin

The Appearance of Anonymous Man, 1949. Photograph. Courtesy The
Historic New Orleans Collection, accession no. 1983.247.1.437.

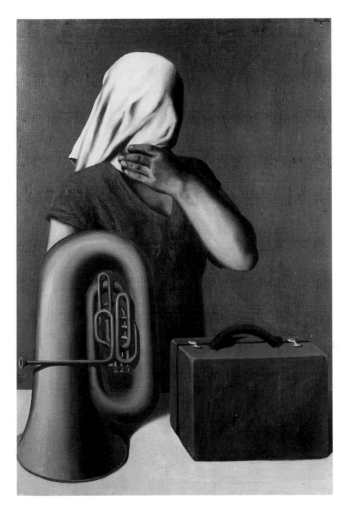

René Magritte

The Central Story, 1928. Oil on canvas, 116 × 81 cm. Courtesy
Galerie Christine et Isy Brachot, Brussels. © 1999 by
C. Herscovici, Brussels / Artists Rights Society (ARS), New York.

René Magritte

The Therapist, 1937. Oil on canvas. Private Collection, Brussels.
Giraudon / Art Resource, New York. © 1999 by C. Herscovici,
Brussels / Artists Rights Society (ARS), New York. Courtesy of
Giraudon / Art Resource, NY.

René Magritte

God on the Eighth Day, 1937. Photograph. Courtesy Galerie Christine et Isy Brachot, Brussels. © 1999 by C. Herscovici, Brussels / Artists Rights Society (ARS), New York.

Walker Evans

Gas Station, Reedsville, West Virginia, 1936. Photograph. Library of Congress,
Washington, D.C.

Stuart Davis

Report from Rockport, 1940. Oil on canvas, 24 × 30" (61 × 76.2 cm). Courtesy of The Metropolitan Museum of Art, New York. Edith and Milton Lowenthal Collection. Bequest of Edith Abrahamson Lowenthal, 1991. (1992.24.1). © Estate of Stuart Davis / Licensed by VAGA, New York, NY.

We know from the overlapping of objects and perspectival cues that the phone sign is several feet from the camera and the gas station several yards further. Nevertheless, the space between the telephone sign and the sign on the wall seems collapsed, the two signs tend to draw together on the same plane. This is primarily the result of the photograph's flatness, but it is enhanced by another factor. Lettering implies a surface; lettering on a painting will tend to counteract any tendency toward spatial illusion, for it calls attention to the surface of the canvas on which the letters are painted (e.g., the lettering of the early paintings of Jasper Johns counteracts their painterly illusionistic surfaces). The lettering in a photograph can have a similar effect. When we look at a photograph with lettering, the letters can be seen as being on the plane of the photograph's surface. In Evans's image the words "Motor Co." and "American Gas" detach themselves from the wall across the street and gravitate to the surface of the photograph, however we might try to relegate these words to their proper place in the picture plane.

Although some of the effects may be similar, the lettering in Evans's photograph is generated differently from the lettering in a painting by Johns or by Stuart Davis, and this affects our response. When in Davis's *Report from Rockport* we see that a sign for gas in the foreground and a garage sign in the background seem to rest on the same plane, our perception may conflict with the minimally implied pictorial depth of the painting, but it does not conflict with Davis's vigorous emphasis of the surface. We are not surprised to read the signs as existing on the same plane, since Davis's heavily applied paint reminds us that in reality they are both inscribed on the painting's surface. The signs recorded by Evans's photograph, however, are "in reality" on different surfaces, yards apart. The photograph's ability to visually bring them together on the

same plane, in violation of this reality, is intriguing, whereas the corresponding ability of the painting is not. The painting may be inventive and playful in the way it collapses space, but it cannot create the conflict of knowledge and perception we find in the photograph.

Another way photographs can transform our perception of space is by making space appear discontinuous or fractured. This can be accomplished by using the photograph's two-dimensionality to exploit peculiarities of point of view. André Kertész's *Buy* (1962) is a cityscape taken from a position in front of but higher than a billboard. As a result of this vantage point, the billboard, which shows a smiling woman exhorting us to buy beer, fills the lower portion of the photograph. Beyond the billboard we see a street corner that has a wide sidewalk with arrows painted across it. Two figures, one walking and the other leaning against a stop sign, cast long shadows. This sidewalk scene fills the top of the photograph. The juxtaposition of the flat space of the billboard with the spare landscape of the sidewalk, the lack of a horizon, and the reversal of normal point of view (we usually see billboards *above* sidewalks) all add to the disjunction and confusion of the space shown. The effect is not unlike that produced by the complex spatial disjunctions to be found in certain Hokusai prints, but the shock is greater, since the disjunction is "found" in the world, not composed by the printmaker.

Cartier-Bresson's *Valencia, Spain* (1933) also gives an impression of disjunction. On the right of the photograph we see the right side of a wooden gate to a bullring; it is parallel to the picture plane and cropped by its proximity to the camera. A man with round eyeglasses looks through a small rectangular window in the gate; a brick wall can be seen close behind him. The window intersects the half of a bull's eye design painted on the gate, surrounding the number

André Kertész

Buy, 1962. Gelatin-silver print. National Gallery of Art, Washington, D.C. Gift of the André and Elizabeth Kertész Foundation. © Estate of André Kertész.

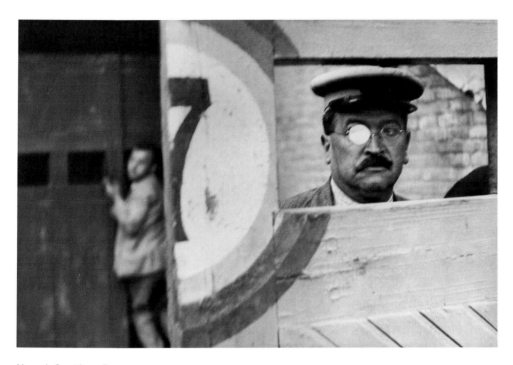

Henri Cartier-Bresson

Valencia, Spain, 1933. Photograph. © Henri Cartier-Bresson / Magnum Photos, Inc., New York.

seven. On the left side of the photograph, past the edge of the gate, stands a boy in the distance, in shadow.

The relations between the space enclosing the man, the space enclosing the boy, and the gate are confusing. Both the man and the boy are located behind the gate, yet one is in light, the other in shadow; one occupies a seemingly shallow space, the other a much deeper space. A correspondence between the man and the design painted on the gate augments the confusion. The white disk of light reflected in the man's glasses echoes the white half circle of the painted design, his shoulder seems to continue the encircling stripes. This correspondence draws the man forward and makes the contrast with the receding space on the left even stronger. It also obscures the relative positions of the gate and the space enclosed by the window.

Because the composition on the right is so flat and light, while that on the left recedes into shadow, because we have no sense of the architectural structure that might encompass both sides of the image or any demonstration of a continuous space that holds man, gate, and boy, the photograph seems a collage of space, but one that puzzles us because we know it shows what is in reality a unified space. We feel compelled to resolve this paradox of what we know and what we see, and this compulsion is linked to the fact that the image is a photograph. If the composition were a painting, we would not be convinced that despite appearances, it really does show a unified space.

When a painting reveals a paradox of space, such as the reflection in Manet's *Bar at the Folies Bergère*, we may try to understand the painting as consistent in its perspective, even though we are bound to be frustrated by its inconsistency. This is part of the interest of the painting. But with such a painting we are interested in how we as viewers are displaced by the incongruities of space, in the

way our attempts to read the painting are destabilized and defy resolution. We are not transfixed by a space we know is unified, although it appears otherwise; we are instead caught up with an impulse to unify that which we may realize cannot be unified.

With a painting, we may know that the image was constructed in such a way that it cannot be read as a unified space, but we still attempt to do so. The painting exposes and disrupts our habitual ways of making sense of paintings. With a photograph, we know that we should be able to read the image as a unified space, but we cannot. The photograph disrupts our expectations by exposing a gap between that which the photograph records and that which it compels us to see. The impact of disjunction in painting and in photography is thus different.

Also very common in photographs are disjunctions caused by reflections. We have already discussed the discontinuous space created by the bureau mirror in Evans's *Street Scene, Brooklyn*. The reflection seems to tear a hole in the street scene, revealing an incongruous, intruding space. While reflections in mirrors create discontinuities, reflections in glass can create an intermingling of spaces. Eugène Atget's photographs of storefront windows, such as *Magasin, avenue des Gobelins* (1925), have this effect. The mannequins in the storefront window emerge through the reflection of the street in the glass. The reflection and the directly observed window scene cannot be sharply disentangled; they seem to merge.

This prevalence of reflections in photographs is matched by a prevalence in photo-realist paintings, but in each medium the effects are very different. This is not just because the image of reflection is generally flatter, more broadly defined, and more opaque in paint. It is also because these differ-

Eugène Atget

Magasin, avenue des Gobelins, 1925. Albumen-silver print, $9^3/8 \times 7"$ (24×18 cm). The Museum of Modern Art, New York. Abbott-Levy Collection. Partial gift of Shirley C. Burden. Copy Print © 1998 The Museum of Modern Art, New York.

Richard Estes

Cafeteria, 1970. Oil on canvas, $41^{1}/_{2} \times 48^{1}/_{2}$". Collection Edward J. Minskoff. Photograph Courtesy Allan Stone Gallery, New York. © Richard Estes / Licensed by VAGA, New York, NY / Marlborough Gallery, New York.

ences in the image, along with differences in the format of presentation, alert us to the fact that we are not looking at a photograph. (These differences are much less pronounced, or even obscured, in photographic reproduction, so the identity of the medium is less obvious.) A Richard Estes storefront window painting, such as *Cafeteria*, in some ways captures the look of a photograph, but it is still very clearly a painted image. The ambiguities it creates may be derived from photography, but they are not the ambiguities of photography. The Atget photograph gives us the excitement of seeing a surreal intermingling of spaces emerge from the world we inhabit. Estes's painting, because it is seen as a painting, illustrates this photographic phenomenon; it does not duplicate it.

This difference in impact between the two media might explain why the most confusing discontinuities, such as those displayed in *Valencia*, are more likely to occur in photographs than in photo-realist paintings. Photographs have our confidence in their veracity, whereas the veracity of paintings is always open to question. The stronger the defamiliarization of a photo-realist painting, the more likely we are to question the correspondence of the image to reality—or to a photograph—and the less "photo-realistic" it becomes.

Not only can photographs transform space, they can also transform movement by freezing an instant of time. As I have previously discussed, Cartier-Bresson's *Behind the Gare St. Lazare* (1932) captures a man jumping over a puddle in mid-leap, allowing his image to be matched by the leaping figures on the circus posters in the background. Both he and the figures on the posters are reflected in the puddle. The fortuitous matching of movements and repetition of images delight us; but the same composition in a painting would not seem fortuitous, it would appear contrived. What for the photographer is a coup of tim-

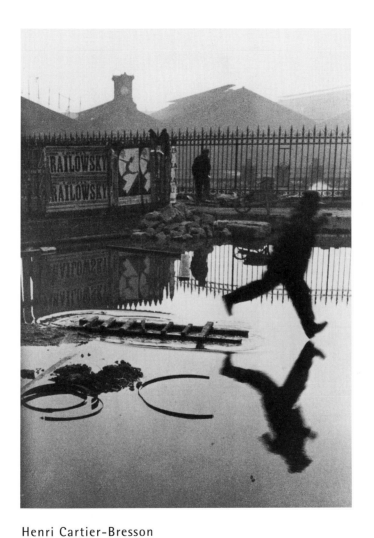

Henri Cartier-Bresson

Behind the Gare St. Lazare, 1932. Photograph.
© Henri Cartier-Bresson / Magnum Photos, Inc., New York.

ing and positioning can seem strained and lacking in subtlety when constructed by a painter.

The differences in our reactions to paintings and photographs do not rest on differences in precision, persuasive detail, or compelling composition, although these characteristics can certainly be important. The fundamental difference in our reactions rests instead on our disparate beliefs about the genesis of each image. The fact that the difference in impact between paintings and photographs seems undiminished when they exhibit comparable precision and detail (for instance, Estes's and Atget's images of reflections), or when they are very close in tone and subject (for example, Magritte's painting and his photographic study), suggests that the critical factors in our reactions to each medium are the beliefs and expectations we bring to them.

By considering the genesis of images in each medium, we can come to understand both photography's distinctive impact and painting's special strengths. Although painting might not have photography's surreal power, it has its own rich potential to show anything the painter can imagine. The painter has the freedom to extend the pattern of a tablecloth across the wall of a room (Matisse's *Harmony in Red*), or to make the clouds of a painting continuous with the sky behind it (Magritte's *Human Condition*), or to give the sky the same texture as a field (van Gogh's *Road with Cypress and Star*), or to show monstrous fantasies (Bosch's *Garden of Earthly Delights*). These things delight us as products of human invention. Painting also gives a pleasure in its modeling of appearances that photography does not give. A seventeenth-century Dutch painter's mastery of the translucency of glass, the texture of carpet, or the shine of pewter and of pearls delights us because we know it is a construction of

paint, whereas the mass of detail provided by a photograph delights us because it is "real."

Photographic Paintings and Painterly Photographs

The difference between paintings and photographs can be thrown into even sharper relief by further considering photo-realist paintings, which are made from photographs and which also adopt the "look" of photographs. Given our knowledge of how they are made and given their photographic look, shouldn't these paintings behave like photographs—shouldn't we read them as photographs?

Photo-realist paintings have a photographic look, but no one is likely to actually mistake these paintings for photographs (except when viewed in photographic reproduction, but this will be discussed later). The comparatively broad handling of color and detail, the relative flatness and opacity of the image, and, most especially, the properties of the painted surface normally prevent us from making such mistakes when we view the paintings in person. And even if we fail in our observation of these features, the scale and format of presentation will normally set us right. Photo-realist paintings are paintings of photographs, they make us think of photographs, but they are not easily confused with photographs. And although photo-realist paintings may be *about* the way photographs transform reality, that does not mean the paintings transform reality themselves.

We already saw this distinction with respect to photo-realist paintings of reflections, which call our attention to the effect of reflections in photographs, but do not duplicate that effect. The intermingling of planes in a painting such as Estes's *Cafeteria* is seen as corresponding to what happens in photographs, and

Chuck Close

Robert/104,072, 1973–1974. Synthetic polymer paint and ink with graphite on gessoed canvas, 9 × 7'. The Museum of Modern Art, New York. Gift of J. Frederic Byers III and promised gift of an anonymous donor. Photograph © 1998 The Museum of Modern Art, New York.

to that extent, as corresponding to reality, but the specific image of intermingling we are presented with is seen as the product of art, not the capturing of a strange aspect of reality.

That the reflections and the directly observed objects in the Estes painting have an equivalent presence is not surprising since, however pictorially disjointed, they are contiguous elements of the same homogeneously painted surface. On the other hand, the achievement of an equivalent presence in photography *is* surprising. We do not see the elements of Atget's image simply as contiguous elements of the homogeneous photographic surface; the elements are instead related back to the real world of mannequins and reflections. We seem to see the mannequins, we seem to see the reflections, and their casual intersection and intermingling seems at odds with their heterogeneous ontology.

Photo-realist paintings not only behave differently from photographs, they can even subvert our notions about the realism of photographs. In Chuck Close's *Robert*, the tiny grid Close used to assist him in copying the photograph is left visible, so it reminds us that what we are looking at is a painting and not a pho-

tograph. To this extent, the grid detracts from the painting's photographic effect, but at the same time it creates the sense of an exact mechanical transference. The grid enhances the sense that the painting is faithful to the photograph and hence faithful to reality. But this last move is also undermined by the painting— the enlargement of the image seems to highlight the photograph's divergence from reality: it emphasizes the shallow depth of field that results in the nose being blurred. Instead of acquiring the documentary status of a photograph, this photo-realist painting undermines our faith in that documentary status.

The knowledge that a painting was made from a photograph should give it no greater credence as a document than the knowledge that a painting was made from life. In both cases, the world, or one of its documents, is interpreted by an artist who has creative control. So a photo-realist painting, insofar as it is recognizably a painting, is no more able than any other painting to partake in the double vision of photography.

Still, what about the hypothetical example of a painting that *does* fool us? What if we were to be confronted with a painting that convincingly projected the illusion of being a photograph? To the extent that a painting is a successful imitation of a photograph, and to the extent that we cannot resist seeing it as such, the conventions of photography would come into play. The knowledge, though, that we were really looking at a painting would lead to a different sort of double vision—we would know it to be a painting, but see it as a photograph. Such a double vision could lead to a shifting of responses and an instability of readings.

Not only are there paintings that look like photographs, there are photographs that look like etchings, watercolors, or charcoal drawings. This is usually achieved by a combination of techniques, such as painterly composition, soft focus, multiple printing, textured paper, and manipulating the

emulsion before it dries, as can be done with gum bichromate prints. Gertrude Kasebier's *Serbonne (A Day in France)* (1901) and Edward Steichen's *The Pond-Moonlight* (1904) both use these techniques to painterly effect. Perhaps most striking, though, is George H. Seeley's *Winter Landscape* (1909), an image of snow on a frozen pond. It requires a great effort to see this photograph as a photograph, rather than as a charcoal drawing, so simple and abstract is the image, so rough its surface, and so coarse the transitions from black to white.

We read photographs and paintings differently not simply because of differences in the way they look and not simply because of what we know about their genesis—the two reasons are interrelated. Presumably we see photographs as documents because of the mechanical production of their image, but the detail and precision typical of that image allow for the confusion of the documentary and duplicatory functions discussed earlier. If all photographers used, for example, the painterly techniques of Seeley's and Kasebier's gum bichromate prints, it is not clear that photographs would be given that much greater credence than paintings as indicators of how things look. So, photographs elicit a different set of conventions from paintings because of differences in how they are made *and* in how they typically look. Photographic paintings and painterly photographs complicate the picture.

Given this, what ultimately determines how we treat any particular image whose appearance misleads us? The way it looks or what we know to be its origins? Again, the two factors are interrelated. How something looks determines whether we will see it as a photograph or a painting or drawing. To the extent that our knowledge of the image's genesis contradicts how we see it, our reading of the image will be subverted or unstable.

Gertrude Kasebier

Serbonne (A Day in France), 1901. Gum bichromate print, 12 $^{3}/_{8}$ × 9 $^{5}/_{16}$"
(31.5 x 23.6 cm). The Museum of Modern Art, New York. Gift of Mrs.
Hermine M. Turner. Copy Print © 1998 The Museum of Modern Art,
New York.

George H. Seeley

Winter Landscape, 1909. Gum bichromate over platinum print, varnished, 17 3/8 × 21 1/4". (43.7 × 53.9 cm). Gilman Paper Company Collection.

Altered Photographs

Painterly photographs are just one indication that the categories of painting and photography are not clear-cut. Not all photographs straightforwardly record what is in front of the camera. Combination printing, double exposure, and re-touching, among other techniques, allow the photographer to put together an image not found in life. But such alteration has been relatively rare and re-stricted in use, and unless there is obvious evidence of manipulation, we nor-mally assume we are dealing with straight photographs.

But there are cases where manipulation is obvious. In such cases the aura of veracity is usually, but not always completely, destroyed. For example, the use of multiple exposures or montage can prevent us from reading a photograph as a record of the world. Consider Clarence John Laughlin's *The Masks Grow to Us* (1947), which uses multiple exposures to suggest a woman's face becoming a doll's face, a mask. Because the manipulation is obvious, the image seems con-trived to illustrate an idea; we cannot read it as revealing something about the world. *The Masks Grow to Us* simulates the physical transformation of person to representation, whereas *Torn Movie Poster* achieves the perceptual transforma-tion of representation to person. Laughlin presents us with a fictional object, whereas Evans makes us see a real object differently.[19]

Wanda Wulz's *Cat and I* (1932) also uses a multiple exposure, but this time the faces of a woman and a cat are combined to form a haunting image whose component elements are difficult to disentangle. Although it is an obvious su-perimposition, it works so well to fuse the images that we are held by the un-canny mixture, unable to disentangle the components. There seems to be some deep congruence of woman and cat. For this reason, the photograph,

Clarence John Laughlin

The Masks Grow to Us (1947). Photograph. Courtesy The Historic New Orleans Collection, accession no. 1981.247.1.799.

Wanda Wulz

Cat and I, 1932. Gelatin-silver print, 11⁹/₁₆ × 9¹/₄". (29.4 × 23.2 cm). The Metropolitan Museum of Art, New York. Ford Motor Company Collection. Gift of Ford Motor Company and John C. Waddell, 1987. (1987.1100.123).

though an obvious composite, does nevertheless seem to have a revelatory aspect.

Even when the mechanics of alteration are virtually imperceptible, the subject matter can make the fact of alteration obvious. Jerry Uelsmann is known for his elegant and complex photomontages that look like unaltered photographs, such as his untitled 1978 photomontage that shows a sky of shimmering water. What is interesting about Uelsmann's surreal images is that they give us fantasies with the look of straight photographs, as though he had photographed his dreams. This surprises us; we do not expect seemingly straight photographs to show us fantasy images.

But once the subject matter alerts us to the fact that these images are not straight photographs, they for the most part cease to function as such. The direct and convincing nature of his images may continue to compel our vision, but the ties to our world are broken. Because these images are obviously not from life, we accept them as surreally vivid fictions; we do not see them as revealing to us some strange aspect of reality. If we did, we would see his 1975 photomontage of a disembodied eye, surrounded by what seem to be dried grasses that take on the appearance of flayed skin, as more grotesque than we do. This seeming "eye of providence" is more curiously intriguing and disconcerting than grotesque, because we realize we are seeing a "photograph" of someone's imaginative vision. In this respect, the effect is closer to painting than to photography.

Uelsmann's affinity to Magritte gives us yet another opportunity to show that the difference in our reactions to paintings and photographs resides in our beliefs about their origins. Uelsmann's 1991 photomontage, which shows a woman with a white cloth draped over her head and clinging to her body, might be compared as similar in subject to Magritte's *Therapist* and its photographic

Jerry N. Uelsmann

Untitled, 1978. Photograph. © 1978 Jerry N. Uelsmann.

Jerry N. Uelsmann

Untitled, 1975. Photograph. © 1975 Jerry N. Uelsmann.

Jerry N. Uelsmann

Untitled, 1991. Photograph. © 1991 Jerry N. Uelsmann.

study. Uelsmann's image, too, seems to show a void, through bars, where a part of the body should be (in this case the face). But we can see that this void must have been achieved by altering the image. In Magritte's photographic study, as in the photograph of J. P. Morgan, we can see how scenes in the real world, whether contrived or spontaneous, can appear transformed by photography. The distortions of photography show us a world we recognize as our own, in a strange new light. Insofar as the Uelsmann photograph is quite readily identified as composite rather than straight, and insofar as the void it shows is seen as constructed rather than recorded, it does not seem to reveal something strange about our world, but rather to present a mysterious world of its own. In this regard, its impact is closer to Magritte's painting than to his photographic study.

Not all alterations are so obvious as to destroy an image's documentary aura. For instance, very sophisticated yet virtually undetectable alterations can be achieved using digital means. In some of her most haunting work, Nancy Burson uses a computer to combine digitized photographs of children with those of dolls. The results are startling and eerie, as when she shows us a child with the eyes of a doll. Because the alteration is not readily evident, we have a tendency to read these images as unaltered and to be fascinated by them in the way that we are fascinated by, for example, Diane Arbus's portraits. This is the case even though we know that Burson's images are digitally manipulated.

Digital manipulation might thus seem particularly conducive to photographic transformation, since very complicated alterations can be achieved without destroying the image's documentary feel. But at least in Burson's case, the effect achieved by alteration is not one of transformation. Photographic transformations make the familiar, a doll or a child, strange to our eyes. For instance, in Ben Shahn's photograph *Wife and Child of Sharecropper* (1935), a woman holds a

child in one arm and a doll in the other. We are tempted to see the doll as a child and the child as a doll. In Burson's photographs, however, we do not see a doll as a child or a child as a doll; instead we see a hybrid being, a monstrous conglomerate. Burson's images seem to document a new being, half-doll and half-child, rather than to transform a child or doll. Although computer alteration can achieve powerful effects, it does not necessarily facilitate the sort of photographic transformation we have been considering.

Straight photographs, altered photographs, and paintings admit of different readings, and these different readings result from the different conventions we bring to viewing—but conventions can change. Our present conventions and expectations depend on ideas we have about how photographs and paintings are typically generated. If altered or digitally manipulated photographs were to become the norm, our ways of reading photographs could change significantly. (We return to this issue in Chapter 5.)

I have argued that the photographic animation of representations depends on the equivalence that photography creates between people, objects, and their representations. This equivalence depends on the divergence of the photograph from reality—its two-dimensionality, lack of motion, and so forth. But the powerful effect of this animation depends on the fact that we see the photograph as a record, and we thus see the animation as somehow real, not just as the fabrication of someone's imagination. It is because we think of the photograph as a record that we seem to see a part of the real world transformed, that we see a picture-woman or a gargoyle come to life. But this is not all. The animation of representations is just one of the most striking examples of a more general phenomenon: photographs show us the world we know, but changed, made strange. A houseplant, a cityscape, a man holding a hat can all be transformed

Nancy Burson

Untitled, 1988. Computer-generated portrait, Polaroid Polacolor
print, 24 × 20". © 1988 Nancy Burson.

by the photograph's flatness and vantage point, its use of cropping and choice in lighting. But despite all the changes wrought by the photograph, we think of the photograph as providing a record of our world. This is one of the central fascinations of photography: its power to "document" an unfamiliar world that is at the same time *our* world, transformed.

Perhaps photographs cannot be correctly understood as possessing a special documentary status; nevertheless, that is how they are experienced. It is in this respect that photography and painting diverge. And insofar as the recognition of this divergence is necessary to a well-grounded evaluation and understanding of the photographs that we have been considering, it must be reflected in the critical principles we bring to bear.

3 | Transformation in Film

Film, as well as still photography, plays extensively with the ambiguous status of images. Film, however, requires a separate discussion because it has its own characteristic methods of creating and using ambiguity: the sound, movement, and narrative structure of film create distinctive obstacles and opportunities. Furthermore, both live and animated films play with ambiguity and transformation, but to different effect. As we shall see, a comparison of these two media reinforces the analysis of the distinction between the photographic arts, on the one hand, and the arts of painting and drawing, on the other, that I have already proposed.

Methods of Transformation

Shall We Dance is a typical Astaire–Rogers film: a brash Astaire runs after an initially hostile Rogers in a plot complicated by numerous misunderstandings. The film is of interest here because it plays extensively with the relations between representations and real persons. Not only is every main character introduced first by a photograph or painting, but the plot turns on a confusion of a representation, a mannequin, for a real person.

The film opens in a class at a ballet company. A messenger boy passes by the dancers and into the foyer, where he pauses to look at the large portraits of ballet dancer Fred Astaire and impresario Edward Everett Horton that hang there. As the boy embellishes the Horton portrait with a moustache, he is confronted by Horton himself entering the building. After dealing with the boy, Horton proceeds to the room of his star dancer, Fred Astaire. Astaire has a flip-book of musical stage star Ginger Rogers dancing, and when at the end of the scene Horton flips through the book, we see the moving images dissolve into a "live" shot of Rogers dancing with her partner. These pictorial introductions establish, in the very first few minutes of the film, the interplay between representation and real person as an important theme.

Later in the film, a newspaper image of the ocean liner Astaire is sailing on dissolves into a shot of the ocean liner itself, and a table-side portrait of the fiancé Rogers is awaiting dissolves into a shot of him, in person, about to knock at her door. The film's finale takes this association of representation and real thing or person even further: in the number "Shall We Dance," Astaire, unable to dance with the real Rogers, dances with dozens of women holding Rogers masks up to their faces. The film has come full circle. It starts with Astaire

Shall We Dance

Fred Astaire with masked dancers. Film Stills Archive, The Museum of Modern Art, New York.

falling in love with the pictures of Rogers in a flip-book and ends with his danc-
ing with dozens of her images. Of course, one of the masked dancers turns out
to be Rogers herself; a congruence of representation and represented is finally
achieved.

In the film, the most extended example of the substitution of a representation
for a real person, and the most extended example of ambiguity, occurs during a
scene in which Astaire and Rogers are "framed." A realistic mannequin of
Rogers, dressed in a negligee, is posed on the bed of the sleeping Astaire. A very
convincing photograph is then taken and released to the press as "proof" that
the two are married. We can well believe the effectiveness of the newspaper pho-
tograph, for even after we have watched the mannequin being carried around
and posed by the conspirators, and even before we have seen the resulting pho-
tograph, we feel taken in by the mannequin's animate quality.[1] The film, like the
photograph, works its own transformations. The mannequin startles us not sim-
ply because it looks so much like Rogers, but also because it is hard to see it as
simply a mannequin. Through film, the mannequin is transformed.

The tools for transformation within film are much like those for still photog-
raphy previously discussed. The two-dimensionality of the screen image, the re-
duction of colors to shades of gray in black-and-white film, and the creation of
an expressive aspect through dramatic angles and lighting can transform man-
nequins, statues, paintings, and billboards. But film faces challenges not shared
by still photography. First and foremost, since film presents motion, it preserves
one of the essential differences between representations and animate beings:
the latter move while the former are generally immobile (exceptions would
include marionettes, wind-up toys, and mechanical window displays). Further-
more, since the film camera moves, it can reveal the distinction between two-

and three-dimensional objects. A painted backdrop or a painting will be revealed as two-dimensional.

The presence of sound in film presents a second barrier to transformation. Animate beings talk and make noise, but their inanimate counterparts can usually make only mechanical sounds, at most. The presence of sound accentuates the gulf between animate beings and inanimate representations.

Finally, in traditional narrative film, representations are rarely given the sort of attention, within the frame or within the narrative, that facilitates anthropomorphism. In a photograph, a statue is just as good a subject of attention as a person; but in a narrative film, people, as performers of actions, are the focus, and objects take a back seat.[2]

There are many ways in which films can overcome these obstacles to transformation and increase the appearance of equivalence between people, things, and their representations. To overcome the obstacles with respect to movement, marionettes and mannequins can be put into motion, camera movements can give stationary objects the illusion of motion, and statues can be photographed at dynamic angles or juxtaposed with stationary people. To overcome obstacles with respect to speech, musical interludes or asynchronous sound can be used to place mute objects and articulate beings on an equal footing. And finally, the placement of a shot of a representation within a particular sequence of images or within an emotionally charged context can facilitate anthropomorphism.

All of these means are made use of in a striking scene from Renoir's *Rules of the Game*. During an entertainment at his château, Robert, the Marquis de la Chesnais, steps onto the stage to proudly announce a new addition to his collection of mechanical instruments. The curtain rises, revealing an orchestrion with its garish lights, its ornate decorations, and its three mechanical figures, each

holding a bell or baton. As the orchestrion plays, the camera tracks slowly across each moving figure, resting finally on Robert, whose face beams with pride.

This sequence's effectiveness depends in part on its use of the techniques for encouraging equivalence just described. The mechanical figures move as they strike the bells or shake the baton, participating in the music that fills the room; by contrast, Robert stands by, smiling but silent. Furthermore, the movement of the camera in the tracking shot, together with the use of medium close-up, allows the revelation of the scene part by part. As a result, the scene has a depth that it would not have had had it been presented all at once, in long shot. The scene in long shot might have allowed us to see the Marquis's presentation as touching and absurd, but it would not have allowed for the juxtaposition of his face with the faces of the mechanical figures, or for the shock of his overflowing joy following upon their blank expressions. The sequence of images brings out comparisons and suggestions that would not have been expressed by the event alone.

Although the orchestrion figures do not actually seem alive, there is a suggestion of equivalence created by their juxtaposition with the marquis. It is this suggestion which explains why we are startled by the marquis's emotion-filled face. The strategic placement of faces, animate and inanimate, in the sequence proposes equivalence; the contrast of expressions shatters it.

Two additional strategies that film can use to overcome obstacles to transformation merit special attention. One of the most interesting ways film overcomes distinctions with respect to movement is to show moving representations—films within films. And one of the most common ways that film draws our attention to representations is to make the confusion of real things and representations an explicit part of the film.

Films within Films

There are many uses to which a film within a film—an embedded film[3]—can be put: it can serve as a commentary on the activities within a film, it can be used to indicate what a character is thinking about (or what he or she is made to think about), or it may serve a purely narrative function.

For example, in Hitchcock's *Rebecca*, the embedded film provides ironic commentary. The tension and unhappiness of the newlyweds are thrown into sharp relief as they (and we) view their light-hearted former selves in the home movie of their honeymoon.[4]

By contrast, in *Sabotage*, Hitchcock uses an embedded film to tell us what the protagonist is forced to think about: the person responsible for her brother's death. We can follow the thread of her thoughts as she is tormented by the cartoon, *Who Killed Cock Robin?*, playing in the theater she runs with her husband.

In Keaton's *Cameraman*, the embedded film plays a pivotal narrative role. While viewing newsreel rushes the heroine discovers, at the end of a reel, footage of a motorboat accident and her own rescue. In this way she learns that she has mistakenly credited the wrong person with saving her life.

There are many examples of these as well as other functions that embedded films serve in works as diverse as Wilder's *Sunset Boulevard*, Fellini's *8 1/2*, Allen's *Purple Rose of Cairo*, Almovador's *Matador*, and Tornatore's *Cinema Paradiso*. In each of these, the use of embedded films provides a wealth of creative opportunities; however, in some of the most interesting cases, it leads to ambiguity.

When an embedded film is shown full screen, it can be impossible percep-

tually to tell that it is an embedded film. All the techniques that can draw attention to the fact that we are looking at a film can be attributed to the containing film rather than to an embedded one. In such cases, the fact that we are looking at an embedded film must be made known contextually, for instance, we see people going into a theater or we see shots of an audience. (Another sort of contextual factor is our recognizing a clip from a well-known film.)

In other cases, we are given perceptual clues that we are looking at an embedded film: it is in black and white whereas the containing film is in color; we see the heads of the audience in front of the screen; or we see fragments of the darkened room in which the film is projected.

Even when there are perceptual clues, an embedded film can command a presence equal to or greater than that of the containing film. It holds our attention by providing the action, while the surrounding theater or room is in shadow. But perhaps the most striking use of an embedded film is to allow the action of a scene to be visible next to or in front of a projected movie. This can result in a struggle for our attention between the "live" people and the "filmed" people, and a blunting of the distinction between the two or an apparent reversal in their status. The last scene of Augusto Genina's *Prix de Beauté* (1930) provides a powerful example of this setup. Lucienne, played by Louise Brooks, is shot and killed by her jealous husband while she is screening her new film. The closing shot shows the lifeless Lucienne in the foreground, with her film image, very much "alive," singing in the background. This scene is so wrenching precisely because on screen the woman and her image seem equal in presence—the singing Lucienne seems

Prix de Beauté

Louise Brooks, foreground and background, in the closing shot. Courtesy George Eastman House, Rochester, N.Y.

at least as real as the dead Lucienne—and this paradox increases the viewer's sense of loss.

Another striking example of the blurring of the distinction between live and filmed action occurs in Hitchcock's *Saboteur* (1942). As the saboteur shoots it out with the FBI in front of the movie screen at Radio City Music Hall, the gun shots and horror on the screen become intertwined with the gun shots and panic in the theater.

At the beginning of the sequence, we see an FBI agent standing in the theater against the backdrop of the movie screen, which shows the closeup of a gun. As a character in the embedded film says "I've caught you at last, you rat in the grass," the gun on the embedded screen fires. We then see that a man in the Music Hall audience has been shot, apparently by the saboteur, whose gunfire was covered by the gunfire of the embedded film.

We then see the tiny figure of the saboteur in front of the huge Music Hall screen. He shoots, and smoke rises from his gun as the man on the embedded screen says, "Get out, before I shoot again." The audience, now aware of the real gunfire, begins to flee the theater. The saboteur moves back and forth in front of the screen as the man in the embedded film says, "I'll kill the rat if it's the last thing I do." Although a man is speaking, on the screen of the embedded film, dwarfing the saboteur, is a woman's anguished face; she reacts with horror as more shots are fired. The shouts of "run for your life" and "get out" from the embedded film mingle with the frightened shouts of the Music Hall audience as they run to escape the danger. They have been converted from viewers of film violence to witnesses and victims of real violence, a transition made all the more traumatic by the confusing entanglement of the two.

The Confusion of Representations with Real Things

Since film is a narrative art, it can draw attention to representations by making their (often humorous) confusion with real things an explicit part of the story, as in *Shall We Dance*. (In the still arts of painting and photography, with their limited narrative range, this confusion must usually be implicit.)

Although examples of this use of representations can be found in films of all periods and genres, it is particularly prevalent in silent films, where the differentiating factors of sound and color are absent. The confusion of representation for person or person for representation was a standard gag of silent comedies.

The comic ending of the 1917 film *A Dancer's Peril* makes use of just this sort of gag. A young dancer, who has previously posed for a life-size portrait, steps behind an empty frame in the artist's studio. The room is dark, she strikes a pose, and she is, for us, transformed into a painting. The artist, returning to his studio, is fooled by the "painting." As he turns away, the dancer laughs silently and moves—again she is a person, but when the artist turns to take another look, she is once more frozen into a painting. This quite impossible deception (the three-dimensionality of the woman, among other things, would be obvious to the artist) is made believable because, through the two-dimensional film image, *we* can be deceived. Even though we know that it is a real woman behind the frame, when the woman freezes, we see her as a painting.

More common in early film was the confusion of person and mannequin. In *Safety Last*, Harold Lloyd successfully poses as a mannequin in order to sneak into a department store, and by posing as a mannequin in *Daydreams*, Buster Keaton temporarily evades a pursuing policeman. Keaton, in fact, was particu-

larly fond of this kind of gag. In *The Goat*, he dutifully waits at the end of a bread line only to discover, too late, that he is standing behind mannequins set out on the sidewalk to advertise for a men's clothing store. And in *Seven Chances*, he first mistakes a mannequin for a woman, proposing marriage to it, and then mistakes a woman for a mannequin.

Keaton also played with the "animation" of two-dimensional representations. In the Arbuckle short *The Garage*, a cutout of a kilt serves to make the pantless Keaton look properly clothed—until he turns around. In *The Frozen North*, a cutout of a bandit, which Keaton props against the window of a saloon, serves as his partner in an attempted robbery.

This sort of confusion of people and representations did carry over into sound film, as can be seen from the already discussed mannequin sequence in *Shall We Dance*. The Marx Brothers' *Monkey Business* also provides a good example. In that film the stowaway Harpo poses as a puppet in a shipboard Punch and Judy show, fooling his pursuers and amusing the young puppet show audience with the effectiveness of his impersonation. Harpo interrupts his impersonation to silently laugh when the backs of the ship's officers are turned, but resumes his imposture when they look at him. The sequence allows us to witness the transformation several times, much as in *A Dancer's Peril*. (It is not an accident that in this sound film, it is the mute brother who undertakes the imposture. Harpo's silence helps him to import some of the strategies of silent comedy into the Marx Brothers' decidedly non-silent films.)

In a much later film, Louis Malle's *Zazie dans le Metro*, the mischievous child Zazie hides by posing as a mannequin among identical Zazie mannequins, confusing her pursuer. This last example is less convincing than the others, perhaps

because it is in color, but also perhaps because it aims more at mimicking the antics of cartoons than at creating a convincing deception.

Cartoons

The transformation and animation of objects also occurs in the animated film, the cartoon.[5] In fact, many of the gags and confusions that appear in live action film also appear in cartoons, where the scope of transformation is much broader and its occurrence much more widespread. Transformation permeates the cartoon and can be seen as central to its character.

Cartoon transformations take all forms. There are changes of shape and size, as when a character literally shrinks from embarrassment, when his face flattens when hit with a pie pan, or when the body elongates and expands in impossible ways as the character stretches, jumps, or dances. There are also more radical transformations, as when Tweety Bird turns into a monster after drinking a bottle labeled "Hyde" formula (mistaken for "hide" formula) or when all the characters are transformed in fantastic ways by the witch's magic mirror as they dance through the cave in the Betty Boop version of *Snow White*.

The animation of inanimate objects is an especially prominent sort of transformation in cartoons. As "animated film" suggests, cartoons are animate in that still pictures come to life through rapid movement. But cartoons are also "animated" in that every object within the cartoon world is subject to animation and personification. Erwin Panofsky described this aspect of cartoons in "Style and Medium in the Motion Pictures," where he observed that "The very virtue of the animated cartoon is to animate, that is to say, endow lifeless things with life,

or living things with a different kind of life." "No object in creation, whether it be a house, a piano, a tree, or an alarm clock lacks the faculties of organic, in fact anthropomorphic, movement, facial expression and phonetic articulation."[6]

As might be expected, representations are especially prevalent as objects of animation or transformation—whether the singing billboard characters in *Smile, Darn Ya, Smile* (1931), the dolls that come to life in *Red-Headed Baby* (1931), or the picture of a bridge that becomes an avenue of escape for the Road Runner in *Going, Going, Gosh* (1952).

By far the most common form of animation within cartoons, at least in the early ones, is this literal animation: the representations really do come to life or really do become the things they represent. But there are plentiful cases where the animation (or its opposite) is perceptual—mechanical dogs and a real dog are confused for each other in *Curious Puppy* (1939), a puppet is confused for a real mouse in *Mouse Warming* (1952).

Cartoons make even freer comic use of the mannequin/person and picture/real space confusions than did silent comedies. We may do well to compare the way these confusion gags function in film and in cartoons.

To begin, we must distinguish between two versions of the gag. In the first version, we are taken in along with the characters of the film or animation. Their confusion is seen as understandable because we share in it, at least to some degree. We are sometimes even fooled along with them. Most of the film episodes we have considered are of this type.

With the second version, we do not share in the confusion; we are not fooled along with the characters. We laugh at the ridiculousness of the situation and the impossible stupidity of the characters who are fooled. Although this version of the gag is sometimes found in films, it is more often found in cartoons.

For my purposes here, I am more interested in the first version of this gag, where we are surprised and confused by an ambiguity or transformation involving representations. It is not surprising that this version is more common in film than in cartoons. Whereas the ambiguity of a mannequin seen in a film can be truly striking and disconcerting, it is not so striking to see a cartoon mannequin drawn to look as though it were alive. There is little mystery in such cartoon ambiguity, for the cartoonist can make the mannequin as lifelike as the "live" characters portrayed; in fact, the mannequin can literally be brought to life. For this reason, perceptual ambiguities in cartoons are more likely to be viewed as clever than intriguing. Since in cartoons literal transformations are as easy to create as perceptual ones, and since literal transformations can lead to so many free-wheeling narrative and lyrical possibilities, their preponderance is easy to understand.

In comparing film and cartoons, we might think back to the comparison between photographs and paintings made earlier. The claim was made that whereas photographs hearken back to reality, paintings are seen as much more tenuously connected to reality, and the transformations and ambiguities created are more likely to be seen as contrivances of the artist, as pure fantasy. Much the same can be said about cartoons. Whereas films jolt us by the transformation of the real, of the way we see our world, cartoons delight us in a topsy-turvy world that breaks all the rules. When a billboard road becomes an avenue of escape or a park statue comes to life, we are delighted, but not amazed; we see it as part of the freedom that comes with drawing unconstrained by reality.

Of course, transformation within cartoons is even more widespread than I have suggested—it might even be seen as a distinguishing characteristic of cartoons. In cartoons, objects of all sorts can become animate and can change from

one thing to another: a car can open its bumper mouth and laugh, a chair can run away on its legs, a pile of logs can be thrown in the air and return to earth as a fence. The animated film is the medium in which fantastic transformation can reach its fullest expression and best thrive, but it is not transformation of *our* world.

Special Effects

I have discussed above the quite literal animation of objects that occurs in many cartoons, where the objects or representations are shown as really alive or as actually coming to life. Literal animation can also be found in film, most frequently in horror movies, children's films, and fantasies. In these films, special effects are used to create animate toys, statues, and mannequins. These special effects can involve the manipulation of the film, the careful construction of what is in front of the camera, or both.

Most simply, actors can be used to portray toys and statues that come to life. This method is used in Jean Cocteau's *Beauty and the Beast*, in which the statue of Diana comes to life at the end of the film. A woman has been costumed and posed to create a convincing statue but, as we see at the end, one with the power of movement. These statue/humans actually appear throughout the film in the Beast's castle—as the arm candelabras in the hallway and the "carved" faces of the mantelpiece—to eerie effect. Many other films also use human statues or dolls for comic or magical effect. A live statue appears in W. C. Fields's *Million Dollar Legs*, and live toy soldiers and dolls appear in Jean Renoir's *Little Match Girl* and in Laurel and Hardy's *Babes in Toyland*, to name but a few.

It should be noted that this means of animating statues and dolls, though perhaps facilitated by the character of film, does not depend on the special features of film. Costuming, pose, and mimicry can be used to create human statues, puppets, and dolls on stage, as in the ballets *Petrushka* and *Coppelia*. Similarly, a motion picture's use of manipulated mannequins and puppets to create the illusion of live dolls does not depend on the special features of film; puppet shows have long been creating such illusions. Film, however, can enhance the illusion of animation through careful editing and setups.

Other ways in which inanimate objects are made to seem animate, however, do depend more fully on the technology of film. Stop-action photography, double exposures, dissolves, and increasingly, digital manipulation, are among the tools filmmakers use to depict the animation of objects. For example, in Jan Svankmajer's *Alice*, dolls, stuffed animals, and other objects are given movement through the use of stop-action photography. The effect is meant to be taken literally: within the context of the film the objects are supposed to be seen as really animate, and in fact they do seem to possess an eerie life.

Svankmajer's eerie creatures and Cocteau's statues are more compelling than their cartoon counterparts, because we experience a greater realism and immediacy with film than with cartoons. Nevertheless, literal transformations, whether in film or cartoons, undermine the realism of the world presented. In both cases we see an alien world, a fictional world; we do not see our own world anew. We do not see ordinary people as though they were statues or ordinary objects as though they were live creatures. We see entities that are neither the one nor the other—hybrid beings.

Both film and cartoon hybrids differ from the film transformations with which I began this chapter. Without resorting to anything supernatural, those

transformations challenged the ontological distinctions between objects and their representations; they made us see people and statues, puppets and paintings, differently.

A Complex Example: *Sherlock Junior*

Keaton's *Sherlock Junior* deserves a separate discussion, since it not only provides a well-known and complicated case of an embedded film, but also provides an example of a narrative confusion of film world for real world that makes use of both perceptual ambiguity and special effects. In the film, Keaton has been framed for the theft of a watch belonging to his sweetheart's father. He is banished from her house and, after an unsuccessful attempt to discover the real thief, dejectedly returns to his job as a film projectionist. The film that he is showing, *Hearts and Pearls* or *The Lounge Lizard's Lost Love*, is also about a theft and a framing, and the sleepy Keaton sees the characters transformed into his rival, his sweetheart, and her father. It only remains for Keaton himself to appear in the film, and as he falls asleep we see a dream Keaton, incensed by what is happening on screen, walk down the theater aisle, climb onto the stage and jump into the film. Once there, the famous sequence unfolds in which Keaton finds himself in the film but not integrated into it. The film cuts wildly, from a garden, to a jungle, to an ocean, to a snow scene, while Keaton remains on the screen trying to cope with these dizzying changes of environment.[7]

At the beginning of the sequence, as we see Keaton heading through the theater toward the screen, we see the embedded film along with the "real space" of the film—the theater containing Keaton and the audience. The frame is domi-

Sherlock Junior

Keaton, at right, is about to enter the embedded film. Courtesy of The Academy of Motion Picture Arts and Sciences, Beverly Hills.

nated by the embedded film, although our attention is divided between it and the action in "real space": the exasperated Keaton moving closer and closer to the front of the theater. The equivalence here between the real and the represented is perceptual. (It may also be seen as conceptual, for we know that Keaton is reacting to the drama as real. It is also partly literal, because the actors in the embedded film have become the "real" sweetheart, father, and rival.) This equivalence becomes more than perceptual, the real and the represented become fused, when Keaton jumps into the embedded film. However, the fusion is only partial. Keaton is at first kicked out of the embedded film, and when he returns, he is stranded, unintegrated, into its changing scenery. The fusion is made complete only when Keaton finally is integrated into the action of the film within the film.

The fusion is literal, achieved by special effects, but it is interesting to note that the special effects depend partly on perceptual equivalence. Sometimes we see an embedded film, but sometimes we see a stage set that looks like an embedded film. Because of the perceptual equivalence that really does exist between the two worlds, because the set has the same sort of presence that the projected film has, the containing film can switch between the set and the projection—and it works. Furthermore, the ontological status of the Keaton character who has entered the embedded film can be ambiguous because the character within the film and the character within the embedded film would look much the same.

Of course, to the extent that this sequence in *Sherlock Junior* is seen as the magical episode of a dream, it is not an example of the literal transformation of our world. It illustrates the confusion between real and film worlds that bedevil the hero's dreams and pulls us, the audience, along as we become engrossed in the hero's adventures. In this way the episode thematically addresses the notion of transformation as forcefully as any other film, relying on the perceptual ambiguity of the embedded film to succeed in its effect.

Once Keaton, as Sherlock Jr., is integrated into the embedded film, it becomes coextensive with the containing film. We are not reminded that it is only an embedded film/dream sequence we are watching until the very final episode, when Keaton awakes to find that he has been cleared, by the efforts of his sweetheart, of the charge of stealing the watch. A reconciliation takes place, in which the couple in the projection booth is juxtaposed, both by the film and by Keaton, with the amorous couple on the embedded screen. Keaton looks to the protagonist of the embedded film for guidance on how to behave. The man in the film takes the woman's hand, Keaton takes his sweetheart's hand. The man places a ring on the woman's finger, Keaton follows suit. In this sequence, the presence of the couple on screen is the same as that of the couple framed by the window of the projection booth. However, the limitations of this equivalence is made comically explicit when, after bestowing a kiss on his beloved's forehead, Keaton looks up to see his "instructor" on the screen shown years later, married and surrounded by several children. Keaton can only look bewildered by the absence of the intermediate steps.

In *Sherlock Junior*, an equivalence between the world of the film and the world of the embedded film is made explicit both by the hero's ability to physically move between the two worlds (in his dream) and by the narrative interaction between the two realms. But the equivalence is undercut in several ways: by the initial inability of the Keaton character to become integrated into the embedded film, by the disparity between his incompetence as a detective in real life and his competence in the embedded film, and finally, by the insufficiency of the embedded film to serve as a step-by-step guide for life.

Films like *Sherlock Junior* and *Shall We Dance* provide a complex interplay between representations and real things. They demonstrate that even though film

shows the distinctions between inanimate things and animate beings more readily than still photography, it nevertheless has at its disposal the means to create an equivalence or a confusion between the two. In fact, whole conventions of comedy and of expression have grown up around such confusions and equivalences, and entire narratives have hinged on them. What is lost by the moving picture in perceptual equivalence is often made up for by the explicit suggestions of the narrative. I will not here attempt to discover whether these narratives are actually inspired by the perceptual equivalence of the photographic image, or whether they simply adapt the deep-rooted fascination with legends of "live images" to a new, and very conducive, story-telling medium. But the comparison of the effects achieved by live action film, by special effects, and by animated film for the most part upholds the findings we have already made in considering still photography. Although special effects and cartoon animation allow for literal transformations, and although these transformations may seem scary, humorous, or miraculous, they stay within the realm of fantasy. The more a film seems like an objective record, however, the more uncanny the suggestion of an equivalence between animate and inanimate will seem. It is only in live action film, free of obvious special effects, that we seem to see the world we know, but in a new, surprising, and intriguing way.

4 | Photographic Reproduction

In Chapter 2, we noted that Magritte's paintings are not transformed in the ways we might expect when they are photographed for purposes of reproduction; the painted figures do not become animated, the painted objects do not take on a full-bodied reality. Photographic reproductions are typically made, used, and viewed differently from other types of photographs, so they require separate consideration.

Photographic reproductions have their own special set of conventions that address both how they are made and how they are viewed. Since photographic reproductions are intended to provide documentation of artworks, they are usually

made so as to call as little attention to their own photographic qualities as possible, eschewing extreme angles, eccentric framing, and the like. Moreover, they tend to eliminate anything outside the work of art "proper," anything that might distract; the boundary of the photograph usually coincides with the boundary of the work, except in the case of installation shots.

These features of reproductions promote what has come to be considered their appropriate use. We are encouraged to look past the photograph and its properties and to see only the work of art that is presented. We are encouraged to treat reproductions as more or less transparent documents.

But of course, photographic reproductions are not really transparent. They transform the artworks they present, not by animating them as described in Chapter 2, but by reducing them to their photographically transmittable properties. Paintings and sculptures are presented *as* photographs. But despite the distortions inherent in this process, we nevertheless tend to think of photographic reproductions as reliably showing us how works of art look.

Reproductions are thus subject to the same tensions we found in other photographs. They transform their subjects, but at the same time, they are taken as possessing a documentary accuracy. This tension, which in other contexts served to enhance a photograph's aesthetic power, here serves a photograph's power to mislead. The notion that we can look "through" the photograph in order to see a painting, coupled with our tendency to put faith in the documentary accuracy of photographs, only makes us less sensitive to the distortions inherent in photographic reproduction and more satisfied with its indiscriminate use.

Furthermore, the more we uncritically rely on photographic reproductions to show us what paintings look like, the less experience we have of the way in which the media of photography and painting diverge. The widespread prevalence of re-

productions and our faith in their accuracy impair our ability to investigate the differences between the two media. When paintings are seen in photographic form, when they are reduced to their photographically transmittable properties, their distinctive character is lost; and this experience with photographs of paintings can come to inform the way we look at and think about paintings themselves.

Reproductions gloss over the divergences of photographs and paintings and tempt us to do the same. Perhaps this is what allows Joel Snyder and Neil Walsh Allen to dismiss the need for special critical principles for photography, and perhaps this is what enables Walter Benjamin and John Berger to discount important differences between the original artwork and its photographic copies—as will be discussed shortly.

Our study of photographs of representations would be grievously incomplete without an investigation of photographic reproductions. But this is not all. By investigating reproductions, we can better understand the ways in which we have come to think and write about works of art, and better appreciate some of the obstacles that have impeded a more comprehensive and nuanced understanding of the relations between paintings and photographs. Furthermore, by investigating the ways reproductions can mislead, we are better equipped to use them so as to enhance, rather than diminish, our understanding of both paintings and photographs.

Reproduction and the Value of the Original

In "Museum without Walls," André Malraux wrote of the way in which photography has transformed our knowledge of art.[1] The ready availability of photo-

graphic reproductions means that we are no longer limited to what we can see in local museums, what we can garner from hand-drawn reproductions, or what we can remember from our travels. Photographs bring to us the art of the world. Through them, we can become familiar with art in public and private collections all over the globe. And photography, by allowing us to bring together the images of artworks in diverse collections, has also transformed our knowledge by facilitating comparison and analysis. Through photographs, we can compare a painting in the Louvre with one in the Prado, or we can survey the entire oeuvre of a particular artist. According to Malraux, this expanded knowledge and range of comparison have facilitated the reevaluation of different artists and periods of art, and have enlarged our notion of artistic value. He points out that the isolated work of a relatively unknown style will not be appreciated. Photographs, by making possible a familiarity with the whole output of an artist or period, can remedy this situation by allowing us to judge works on their own terms.

While Malraux argues that our knowledge of art and our notion of artistic value have been expanded by photography, Walter Benjamin argues that the nature of artistic value has been fundamentally changed. In "The Work of Art in the Age of Mechanical Reproduction," Benjamin claims that in the face of photographic reproduction, the original artwork can no longer retain the special value and authority it traditionally possessed.[2] According to Benjamin, photography makes available to all artworks the mechanical reproduction that was formerly only available to such objects as cast bronzes and woodcuts. The photograph reproduces everything but the original's presence in space and time, its history. The original's continued value thus depends on the continued importance of its "presence," but it is precisely this importance which is undermined by the widespread acceptance of reproductions. Unlike the original, the repro-

duction can be brought wherever the viewer is, and it is accepted as a suitable surrogate. The remote unique object with a specific history is replaced by a multipliable image that can be distributed and possessed, that is no longer confined to a particular context. The original's unique history is depreciated and its special value and authority, its aura, are destroyed.

John Berger, in *Ways of Seeing*, echoes Benjamin's argument and adds that in the age of photographic reproduction the value of the original artwork—so important for the art market and for the social hierarchies it serves—can only be explained by its rarity. The monetary value of the original can no longer be tied to the uniqueness of its image, and hence, can no longer be tied to the uniqueness of its meaning. Still, we have a need to justify this monetary value as arising from some qualitative difference between the original and its replicas. This need gives rise to what Berger calls a "bogus religiosity." The artwork becomes "impressive, mysterious, because of its market value."[3] The monetary value of the original causes the spectator to imagine that the original gives rise to a unique experience.

Each of these three thinkers focuses on the reproducible images of artworks to the neglect of those properties which resist photographic reproduction, most notably the scale, surface, and weight that contribute to a work's physical presence. And even when the neglected properties are given token acknowledgment, they are not considered essential to our knowledge and understanding of art. This single-minded emphasis on image leads Malraux to present an overly rosy picture of how reproductions function and it enables Benjamin and Berger to mount a politically motivated rejection of the value of the original.

Malraux is only partly right when he says that photographs bring to us the art of the world. They bring to us only certain aspects of that art, what might be

called its images. So while photography has made possible the study of art as we know it today, it has also shaped that study: we have come to identify art with its photographically reproducible image.

It is this identification that is behind the loss of aura which Benjamin describes and which allows Berger to make his extravagant claims about the loss of a unique value for the original. If a work of art is reduced to its photographically transmittable properties, any claim for a special artistic, rather than commercial, value for the original will seem bogus.

Benjamin may indeed be right that works of art have lost their aura in the age of mechanical reproduction, but this loss may itself rest on an inappropriately reductive approach to art. Such a reductive approach is evident in Benjamin's woodcut analogy, which ignores the fact that the multiple prints of a woodcut are not copies of a unique original, whereas the reproductions of a painting are copies—copies that differ from the original in many ways. By the same token, Berger may give an accurate account of the bogus religiosity that can surround an original, but his claim that this is the *only* possible explanation for the value that we still attach to originals rests on the mistaken belief that an artwork's reproducible image is its only possible carrier of meaning.

In this chapter I argue that despite the claims of Benjamin and Berger, the unique value of the original artwork has not been destroyed by photographic reproduction. What *has* happened is that photography has changed, perhaps irrevocably, the way we see paintings and sculptures. It is this fact that makes it so difficult to discover and appreciate the unique value of the original.

I will first discuss the circumstances that have led to the primacy of the reproduction. I will show that our experience with looking at photographs actually conditions how we look at art. I then examine the ways in which photographic

reproductions diverge from originals and argue that the consequences of these divergences for our understanding of individual artworks and movements can be critical. Finally, I briefly consider the ways in which an increased attention to the central role of photography in conditioning how we view art and in disseminating information about art may shed light on the modern history and development of painting and criticism.

The Primacy of the Reproduction

Reproductions not only determine how we know distant and inaccessible works of art; to a large extent they condition our knowledge of *all* art. This is because viewing the reproduction has become the paradigmatic art experience.

Several factors lead to this primacy of the reproduction, not the least of which is that encounters with the original work can be elusive or highly unsatisfactory. Viewing the original can involve such obstacles as battling crowds at a museum blockbuster show, coping with reflections or poor light, or straining one's neck to see a top row of frescoes. The photographic reproduction lets us see what we cannot see firsthand. With an art book, we can view the image under "perfect" conditions, whenever we like and for as long as we like.[4]

Reproductions even condition our firsthand encounters. When we know the photographic image first, it can determine what we see when we look at the original. Afterward, the photograph can determine what we will remember. The poster, the postcard, the color plate come to replace the painting.

There are several ways in which our familiarity with photographic reproductions may determine what we see when we stand before the original. We may

see only what photographs have led us to expect, or less blindly, we may *look* for what photographs have led us to expect. This last phenomenon is described by Susan Lambert in *The Image Multiplied.* "Response to the original is tempered by considerations, perhaps only in the subconscious, of how the image lives up to our vision of it in reproduction. The place of discovery is taken by a search for the anticipated."[5] And even if our familiarity with photographic reproductions leads us, in looking at an artwork, to search for that which is not conveyed by photographs, what we see is still conditioned, though negatively, by a comparison with them.

Finally, there is a more fundamental way in which our viewing of paintings may be conditioned by photography: photographs provide us with a rival set of conventions of image-making. Our heavy exposure to photographs in daily life provides us with models of perspective and composition, with norms for the representation of movement, and more generally, with a distinctive sensibility that inform what we see and how we interpret what we see when we look at paintings. For example, we can find both portrait paintings and portrait photographs that "catch" the sitter in mid-gesture. How often do we think of the difference in import that this capturing of the instant has in each medium? What is quite natural for the modern photograph is contrived for the painting. We might almost say that the painting indulges in a second kind of illusion: added to the illusion of spatial representation is the illusion of spontaneity, of instantaneous recording. But our familiarity with the photographic model can make us insensitive to this second sort of illusion.

To point out photography's wide-ranging influence on our perception of artworks is not to assert that before photographs people always experienced art firsthand. The print was the means by which art images were disseminated in

the past. These illustrations were of course less accurate than photographs in recording how a painting looked, but prints were more upfront about their limitations—there was not the illusion of objective duplication, so there was not as much temptation to accept them as satisfactory substitutes for the originals.[6] Photographic reproductions do carry with them these illusions, and this magnifies their influence.

I have argued thus far that photographs in general and art reproductions in particular condition how we view art. I will now consider the effects of this conditioning by briefly discussing some of the specific ways in which photographic reproductions diverge from the original. It is the primacy of the photographic reproduction *together* with its divergence that transform our perceptions of artworks and that divert us from the "unique value of the original."

The Divergences of Reproduction

Malraux points out that the absence of color in early photographic reproductions limited the kind of understanding that was possible in the study of Byzantine painting. The black-and-white reproduction led to the reduction of the painting to its drawing. Since, according to Malraux, the drawing was bound up in convention whereas the innovations of Byzantine art resided in the use of color, this reduction of painting to its drawing led to an unfair dismissal of Byzantine art as "repetitive and static."[7]

Malraux uses this example to show the importance of the advent of color reproductions, to show how the reduction of paintings to black-and-white images can lead to a distorted evaluation of a whole period of art. But just as the reduc-

tion of paintings to black-and-white images can lead to a distorted understanding, so too can the reduction of paintings to color images. Even color reproductions fail to convey crucial properties of the original works of art, and these failures can lead to distortions in our understanding.

In what follows, I briefly discuss some of the changes effected by photographic reproduction. These changes may, in some cases, be obvious. Less obvious is the way these changes can constitute a major obstacle to our understanding of art. The mere acknowledgment of reproductive divergence does not serve to correct the distorted images we form of art, and it is my intent to show that these distortions can be substantial. (In the interest of space, I confine my discussion primarily to the case of painting; the divergences inherent in the photographic reproduction of sculpture are even more pronounced.)[8]

1. Reproductions do not capture the colors of the original. With new techniques, the accuracy of color reproductions may improve, but still, a photograph can at most show the colors of a painting in a fixed light and from a fixed angle. So, for example, the gold in an altarpiece is reduced to one color among others. Its gleaming incongruity is not preserved.

Furthermore, the goal of reproducing accurate color can conflict with the presentation of the subtle or ephemeral character of a painting. For example, Ad Reinhardt's "monochrome" paintings contain slight variations in color. As one looks at one of his black paintings, squares of different shades of black begin to emerge. The difficulty in seeing these variations, their slow appearance and disappearance as light and angle change, is very much a part of the experience of his work, but it is an aspect that is inadequately conveyed by most reproductions. Reinhardt's paintings are typically reproduced in a way that makes the slight variations of color as distinct as possible.

2. The surface of a photographic reproduction is markedly different from the surface of the original artwork. In reproduction, the texture and bulk of paint are exchanged for flat glossy paper or an iridescent screen. This not only leads to a loss of color and spatial effects, it also prevents us from seeing the way a painting is constructed.

For instance, reproductions do not convey the substantiality of the shapes in Elizabeth Murray's paintings. The thickness of the paint gives the forms a physical presence, an air of necessity. In photographs, these forms have a more arbitrary ethereal quality. And reproductions do not show the texture of the canvas that comes through Francis Bacon's paintings, a texture that conflicts with and subverts their ghostly photographic look. In reproduction, the ghostly look is not subverted.

The change in surface can also lead us to misidentify the materials and medium of a work. For instance, when photographed, the painted surface of a photo-realist painting is replaced by a photographic one. As a result, the reproduced painting might actually look very much like a photograph. When this happens, the dialogue between painting and photography which photo-realism provokes risks distortion, or even suppression.

3. Reproductions do not preserve the scale of the original. In art books, paintings that are of vastly different size are reproduced in images that are roughly the same size. Even when the dimensions of the original are given, the reproduction can mislead.

Whistler's *Arrangement in Gray and Black: The Artist's Mother* looks smaller in reproduction, perhaps because we unconsciously assume that it is comparable in size to the painting represented on the wall behind Mrs. Whistler, and the *Mona Lisa* seems larger, perhaps because its fame leads us to expect something

larger. Reproductions do not have to mislead in this way: installation shots of a gallery give us a sense of the scale of a work, and their more liberal use would to some extent counteract the misleading effects of the use of reproductions.

The scale of a reproduction cannot only mislead, it can also interfere with our understanding of the work of art. A painting that depends on its enormous size for impact, for example, Barnett Newman's eighteen-foot-long *Vir Heroicus Sublimis*, may appear trivial and uninteresting when reproduced on the page of a textbook. But more than its impact is lost. With Newman's work, the very point of the painting is obscured by the reduction of scale, for the painting is partly about that scale, about the visual and visceral effect of a large expanse of color whose boundaries extend beyond our field of vision.[9] Berger could plausibly maintain that reproductions of *Vir Heroicus Sublimis* have the same meaning as the original only if meaning is arbitrarily defined as dependent on image alone.

The change in size can also affect our understanding of a painting's perspective. For instance, the chair at the bottom center of Matisse's *Interior at Nice* is shown from directly above, so that its legs are not even visible, while the tables a little farther away and the sitter on the balcony are shown more from the side. This radical shift in perspective does not make sense in a small reproduction that can be taken in at a glance, but in a large painting that requires a significant movement of our eyes to look down at the bottom or up at the top, the shift in perspective can be understood as corresponding to the shift we would experience as we stand over a chair, looking down at the chair or out across the room.

4. In reproduction, the physical presence of the painting is lost. The importance of this loss is most obvious for works that emphasize their objecthood through size, unusual shape, multiple panels, or the three-dimensionality of painted surface. For instance, in reproduction the border between two panels of

Henri Matisse

Interior at Nice, 1921. Oil on canvas, 132.1 × 88.9 cm. Photograph courtesy of The Art Institute of Chicago. Gift of Mrs. Gilbert Chapman. 1956.339. © 1999 Succession H. Matisse, Paris / Artists Rights Society (ARS), New York.

a Robert Mangold painting will read as a line, rather than as an edge or a boundary between abutting objects. And in reproduction, the palpable weight of a Clifford Still painting is lost. But this loss of presence is no less an issue for traditional easel paintings. Even a full-size reproduction of a Vermeer portrait does not have the physical presence of the original. The reproduction is an image of something that exists elsewhere.

5. The reproduction does not usually show the painting's frame. When we compare reproductions that show frames with those that do not, we see that the presence of a frame tends to remind us that we are looking at an image of an absent object rather than at the artwork itself. On the other hand, reproductions that leave out the frame tend to recall original works on paper—drawings and prints. The absence of the frame allows us to be more satisfied with our reproductions, since we are not so insistently reminded of their limitations.[10] But it is exactly this feature of the absence of frames that is so problematic, that contributes to our tendency to use reproductions as substitutes for artworks and to neglect the divergences between the original and its reproduction.

The absence of the frame also means the loss of its many important functions. The frame mediates between the space of the room and that of the painting. By preventing the immediate juxtaposition of the two, it can facilitate the illusion of pictorial space. When a painting is reproduced without its frame, however, there is nothing to mediate between the image of the painting and the surrounding page; the image is seen to end abruptly at its four edges. This can seriously distort the effect of the painting; in particular, it can lead to a flattening of the image.

The presence of the frame is also sometimes important compositionally and thematically. The doorways, windows, and mirrors within paintings can echo

the frames that contain those paintings. For instance, in Matisse's *Anemones with a Black Mirror*, the very prominent frame of the depicted mirror corresponds to the real frame of the painting. Although the mirror frame is oval and horizontal, while the painting's frame is rectangular and vertical, an echo effect is created. Moreover, the two frames pull together, and an ambiguity or compression of space results. This echo effect, and the resultant compression of space between the two frames, is completely lost in reproductions that do not show the painting's frame.[11]

6. Even when the reproduction includes the frame, the relationship between painting and frame is obscured because the material differences between them are not preserved. Painted canvas and carved wood become continuous elements in the flat photograph.

This uniformity of the photographic surface makes it impossible for us to appreciate the trompe l'oeil features sometimes incorporated in paintings. For instance, depictions of gilded framing and carved casements mediate between the real architectural setting and the painted scenes of the Raphael rooms in the Vatican. Even in person it is hard to tell where the architectural molding ends and its trompe l'oeil extension begins—in reproduction it can be impossible. (Similar problems arise with collage, since it can be impossible to tell, from a photograph, whether a label that appears within a painting is real or depicted, or whether a line that appears is drawn or is an edge.)

7. The reproduction not only fails to convey the function of the frame; it also fails to convey the function of the surrounding wall. The flat surface of the wall is important insofar as it serves as a foil for easel paintings and as a ground or negative space for shaped canvases. In a reproduction, the image of the artwork is flush with the paper on which it is printed and the white that occurs within

Henri Matisse

Anemones with a Black Mirror, 1918–1919 (with frame). Oil on canvas, 26¹/₂ × 21¹/₈".
Corporate Art Collection, The Readers Digest Association, Inc. © 1999 Succession
H. Matisse/Artists Rights Society (ARS), New York.

Henri Matisse

Anemones with a Black Mirror (without frame).

the painting is put on the same plane as the white of the surrounding paper. (Tipped plates—separate sheets of paper glued along one or two edges to the page of the book—ameliorate one aspect of this problem, for they are discontinuous with the page on which they rest and are often differently textured. But tipped plates create their own problems; as the paintings they show become sliver-thin flaps, the sense of physical presence and the illusion of depth are both further weakened.)[12]

The loss of the architectural surroundings also has serious consequences for our understanding of art that interacts with its environment. For instance, the eccentric shape of a fresco or canvas may seem frivolous and arbitrary when its architectural determinants are concealed. Tintoretto's *Assumption of the Virgin*, commissioned for the Scuola Grande of San Rocco in Venice, hangs over a doorway, and the lower center border of the painting is indented to accommodate the door's lintel. In reproduction this lintel is carefully cropped out. The absence of the architectural elements not only leaves the shape of the canvas in reproduction unexplained (giving the misleading impression of an affinity with the shaped canvases of twentieth-century art), but also means that we cannot see the way in which the sarcophagus depicted in the painting seems to rest on the solid molding of the real lintel.

8. When looking at a reproduction in a book, we look down at a page instead of up at a wall or a ceiling. This can interfere with our reading and the appropriate functioning of the painting's perspective. When looking up at a Tiepolo ceiling painting, the perspective corresponds more or less to what we would naturally see when looking up at figures. What we see fits our body's orientation. When we look down at the Tiepolo reproduced in a book, or across at its projection on a screen, we see an image designed to imitate what we see when

we are looking upward—but we are *not* looking upward. There is a contradiction between what we see and our body's orientation, a dislocation that makes us more aware of the technique or artifices of perspective, but robs us of the intended effect.

This change in orientation interferes with much more than our reading of a painting's perspective. For instance, it reverses the dominating position of a portrait that looks down at the viewer: the viewer of a book acquires the position of dominance and control. The book reproduction also reduces the physical sense of top and bottom. Morris Louis's upside-down drips do not seem as unsettling when viewed in a book, and Jackson Pollock's drip paintings do not seem as explosively defiant of gravity.

9. When looking at a photographic reproduction, we lose the ability to move closer and farther away from a painting's surface. This prevents us from discovering the tension between a painting's visual effect and the surface that allows that effect. For instance, we lose the ability to see strong outlines of objects dissolve into fuzzy areas of color as we move closer to a painting and we lose the ability to see a dense textured surface become a deep atmospheric space as we move away. This loss is detrimental to our understanding of the work of artists as different as Velazquez, Monet, and Cézanne (and to our experience of mosaics and tapestries).

Not only is our understanding of art affected by the restriction to properties transmittable by photographs, it is also influenced by the properties photography adds. These can include the mysterious aspect lent to an imaginatively photographed sculpture, the new coherence found in a painting reproduced in black and white, or the interest added by the detail visible in an enlargement.

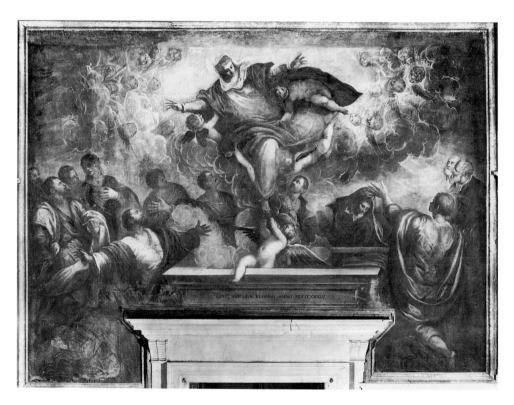

Jacopo Tintoretto

The Assumption of the Virgin, 1583–87. (with architectural context). Oil on canvas. Scuola Grande di San Rocco, Venice. Alinari / Art Resource, New York.

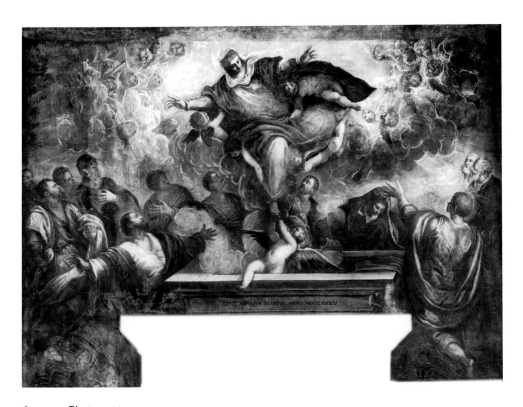

Jacopo Tintoretto

The Assumption of the Virgin (without architectural context).

Malraux recognizes this aspect of reproduction when he speaks of the "ficti-tious" arts created by photography's systematic falsification of scale, its use of the fragment, and use of special lighting. But though he realizes that the interest and the comparisons that result from this fictionalizing are spurious, he does not take this to be a serious problem. This is evident in his acceptance of works that have gained interest only through photographic lighting, enlargement, and fragmentation, as worthy, *in reproduction*, of inclusion in the "museum without walls."[13] The fact that it is only the photograph of the object which has interest is a matter of indifference to him.

The changes brought about by photography do not disturb Malraux because he is primarily concerned with that which, according to him, emerges all the more clearly through the "specious unity imposed on works" by photography—style. He describes how objects as diverse as frescoes and stained glass, as tapes-tries and Greek vase paintings, have become color plates. "In the process they have lost their properties as objects; but by the same token, they have gained something: the utmost significance as to style they can possibly acquire." Since for Malraux it is the story of style that is of overwhelming importance, that con-veys with unparalleled force "the notion of a destiny shaping human ends," the limitations of photographic reproduction become its virtues.[14]

Berger also recognizes the phenomenon of photographic "additions." For ex-ample, he describes how photography, through the use of the detail, allows an allegorical figure in a painting to take on new interest as the portrait of a girl. He also describes how television enables the paintings it shows to take on new meanings as it transmits their images into millions of new environments.

Like Malraux, Berger welcomes these new meanings. But unlike Malraux, he does not acknowledge their spurious nature and excuse them in the interest of

some broader insight they provide about the development of art. No excuse is needed, because for Berger the value of an artwork is just a function of the individual and changing uses of its image. The particular work no longer has a fixed value independent of these.

Both Malraux and Berger speak of the changes wrought by photographic reproductions as enhancing the artworks themselves. Malraux allows for this conflation of a work of art with its photographic incarnation because his interest in art is primarily limited to style. Berger demands the conflation because he is interested in the proliferation of meanings that can be achieved through the recontextualization of an image. But even if we do not limit ourselves to either of these interests, the conflation can occur simply because our experience with reproductions so overshadows our firsthand experiences of art.

Reproduction of the Photographic Arts

Photographic reproduction not only fails to undercut the value of the original with respect to unique works of art, such as paintings and sculptures; it also fails to undercut the value of original multipliable works, such as etchings, cast bronzes—and photographs.

Just as paintings are now most commonly known through reproductions in books and on posters, photographs are also known, not through one of their multiple prints, but through reproduction. Similarly, films are known more and more through their video incarnations. In these cases, the faithfulness of the copy to the original may seem extremely strong, especially since, in the case of a photograph of a photograph, the medium does not change. Nevertheless, im-

portant divergences exist, although their subtlety and relative "invisibility," combined with our greater insensitivity to the artistic parameters of photographs and films, make them perhaps even more pernicious than the divergences in the previously discussed cases of painting and sculpture.

Let us start with a photographic form whose defiance of reproduction is most palpable. Daguerreotypes are unique works whose images require just the right angle of light to clearly emerge. Daguerreotypes lose this elusiveness of image in reproduction, and they lose their characteristic depth of image as well.

Unlike daguerreotypes, photographs from negatives are multipliable, but what we see in books and posters are reproductions of these multipliable images.[15] Reproductions can differ from original photographic prints with respect to surface, scale, contrast, and resolution, and often these differences are interconnected. For example, when the slide of a photograph is projected, the loss of resolution that occurs with the changes of scale and surface can result in the loss of the image's lifelike hold.

There are readily avoidable causes of divergence as well, even in high-quality museum publications. Gustave Le Gray's *Cavalry Maneuvers, Camp de Chalons* (1857) appears in the Metropolitan Museum's catalogue of the Gilman Paper Company collection without a surrounding border: the edge of the page corresponds to the edge of the reproduced photograph. Without a delineating border, the image seems diffuse and unstructured. Furthermore, since it is a two-page spread, the image is divided and "pinched" in the middle. As a result, the spare but powerful composition loses its force.

The image is also compromised by the fact that the paper is insufficiently opaque to prevent the faint outline of the photographs on the reverse side from

showing through. This is especially distracting, since the faint outlines that intrude are as visible as the misty shadows of cavalry men shown by the image.

Even before the appearance of video cassettes and disks, many people knew old films not from the theater but from late-night television. Except for a few cities that have revival houses and some colleges with film schools and film societies, few locations provide the opportunity to see old or small independent films projected on the big screen. Now, with the widespread use of video and with the growth of cable movie channels, the acquaintance with films in their original format is increasingly rare. New films generally play for very brief runs in movie theaters, and their videotapes appear shortly after the films are released. Old films can still sometimes be seen in revival houses, but budgetary problems and a lack of sensitivity to the issues of video transfer have made the use of videotape in college film courses more and more common.

This latter trend is especially alarming, for many of our future filmmakers and scholars, not to mention informed filmgoers, are being educated in an atmosphere that downplays the peculiarities of the film medium. Videotape and videodisc transfers differ from film prints with respect to scale, aspect ratio, cropping of image, color, contrast range, and resolution, among other things.

These differences and their significance are described at length by Charles Tashiro in "Videophilia: What Happens When You Wait for It on Video." For example, he asks us to consider the following hypothetical film sequence.

> A young couple, with their baby daughter, sits next to a window covered by horizontal blinds. Next to the window is an open doorway, leading out into a garden ripe with daffodils in summer sunlight. A butterfly flits across the flowers, attract-

ing the attention of the baby, dressed in a bright red dress. She toddles out into the sun to chase the butterfly as her parents remain in the alternating shadows and shafts of light caused by the horizontal blinds. The mother looks at the father, then says "I think it's time we called it quits" at just the moment their daughter, as she reaches for the butterfly, trips and falls giggling into the flowers.[16]

Tashiro points out that while film can record the contrast of the bright garden and the darkened room without difficulty, video cannot. If the video is exposed to show the parents clearly, the baby and garden will disappear into whiteness. If the baby and garden are shown clearly, the parents will disappear into shadow. If, for the sake of the narrative, it is decided to show the parents, the baby's giggle at the end will seem to come out of nowhere.

A third choice Tashiro mentions would allow everything in the image, both parents and baby, to become visible. But it can only be done by bringing all the tonal values into the middle greys; as a result, the image would look as if it had been "washed with a dirty towel." The visual impact of the scene would be lost.

Tashiro observes that the video transfer of this sequence would run into trouble not only with respect to contrast, but also with respect to resolution and color. The window blinds on video would produce a distracting flicker, since video cannot adequately resolve the pattern of blinds and intervening spaces. The only way to avoid the flicker would be to put the image slightly out of focus. The video image would also have trouble with the red of the baby's dress, for highly saturated reds result in a dissonant "smear."

The relative subtlety of the divergences involved in the reproduction of works in the photographic media, coupled with our lack of sensitivity to them, creates

special problems. Adding to these problems is a lack of concern with faithful-ness to the original. In many quarters, film is still not taken seriously as an art form, as witnessed by the wide acceptance of colorized versions of black-and-white films. Because of this, we not only have to concern ourselves with the un-avoidable divergences of video transfer, we also have to concern ourselves with willful divergences.

Pronounced willful divergence is less tolerated in the reproduction of tradi-tional art: we do not find publishers rushing to colorize Dürer's prints in order to increase the market for their books. When willful divergence does occur (in, for example, a detail shot), it is excused in the interest of other goals (to see what we could see by getting closer to the work of art, not simply to please a larger au-dience). Willful divergences also occur in spoofs and appropriations, but where reproduction is the main goal, the integrity of paintings, prints, and drawings is largely respected. The fact that the *Night Watch* was cropped to fit a frame attests to the fact that painting was not always given such respect. The abridgment, cropping, or coloring of a Hitchcock film for television or for video distribution is today's equivalent of cropping a Rembrandt.

Even when the photographic media are taken seriously as art media, the im-portance of surface, scale, and other properties is still generally neglected, be-cause we live in a society where photographs are most commonly used to convey information—to show us something. Newspaper photographs, illustrations for journal articles and textbooks, ads in real estate circulars, mug shots, and picture IDs, all encourage us to use photographs for the information they give. They are enlarged, reduced, cropped, photocopied, faxed, and digitally transmitted. We bring this experience with photographs to our consideration of photographs as art—no wonder we tend to be so little concerned with the divergences of their reproduction.

Digital Reproduction

Digital reproduction is being used increasingly to store and disseminate information about art. For example, both the National Gallery in London and the National Gallery in Washington have digitally recorded large parts of their collections. Such digital catalogues are not just for archival and scholarly use; computerized visitor centers have been set up to provide information about the collections and exhibits and to allow the visitors to create "personalized tours." In addition, a variety of CD-ROMs, as well as the Internet, are bringing these catalogues to the home computer. For example, Microsoft Art Gallery allows us to peruse the London National Gallery's collection of paintings at home, complete with lives of the painters, a historical atlas, and narrated tours.

William Mitchell argues that "it seems increasingly clear that the days of traditional, expensively color-printed art books and catalogues are numbered. We are entering the era of the electronic virtual museum."[17]

While it is still too early to determine the extent to which digital catalogues will take over the function of art books, and too early to calculate the impact of a switch from photographic to digital formats, some observations are in order on the potential advantages and disadvantages of this new reproductive medium.

The advantages are obvious: digital reproduction gives us instant access to a vast number of images, easily cross-referenced. What used to require a shelf of expensive books can now be contained on a few disks or, in some cases, can be found on the Internet. Digital reproduction also allows us options that are impossible in book form (for instance, we can "walk around" a statue and view it from different angles), and it makes available options too costly and cumber-

some for the average book (for example, we can retrieve a comprehensive set of details of a painting).

Digital catalogues also have the potential to address the contextual difficulties surrounding photographic reproduction. A historically appropriate frame, the original architectural context, or different lighting conditions could be introduced or removed to help us study the importance of these factors.

Because of the vast number of images that can be stored on a disk, as well as the possibility of movement and of audio accompaniment, we can get much more information from digital reproduction than we can get from traditional reproductive formats. But this advantage may also be digital reproduction's key disadvantage. In the digital catalogue, the artwork becomes a nexus of information; it becomes overwhelmed by data. We do not have to address the artwork itself because there is so much to read, so many related images to call forth, so many little boxes asking us to press or click on them so they can reveal their secrets. The reproduced image becomes a site for the collection of data, rather than a record of something sufficient in itself, valuable in itself, that richly rewards our abiding attention. If this is an "electronic virtual museum," it functions more like one of science than of art. Adopting the methods of a science museum, it uses "buttons" next to each painting to demonstrate this or that feature: click here to see the painting's X-ray structure, click there to learn its provenance. The interactivity promoted by the available software, though well-suited to interactive art, distorts our relation to traditional art, discouraging reflective engagement with the object reproduced. In fact, if despite all temptation we spend too long "just" looking at the image displayed, the screen saver will interrupt our contemplation.

Of course, the digital reproduction does not lend itself to just looking, for it

presents an image even more disembodied and distant than a slide or a photographic reproduction. And, at least for the present, the quality of reproduction is inferior to photographic methods (as Bill Gates discovered when he abandoned his project of outfitting his home with digital reproductions). One review of Microsoft Art Gallery complains that "Van Gogh's brush strokes look smudged, and the point in Seurat's pointillism is blotchy."[18] Other problems include the fact that the quality of the color of the digital reproduction and the degree of resolution are dependent on individual hardware. No matter how excellent the production values of the CD-ROM, the images will vary with the hardware used.

The Influence of Reproduction on Art and Criticism

An attention to the central role of reproductions in conditioning how we view artworks and in disseminating information about them may shed new light on modern developments in art and criticism. It would be quite surprising if the wholesale reliance on photographs and slides in curating, teaching, and research had not left its mark on the art world. I will close this chapter with some hypotheses on this topic.

Our dependence on reproductions may at least partially explain the current prevalence of various sociopolitical, psychoanalytic, and semiotic approaches in art history and criticism. These approaches allow scholars and critics to concentrate on those properties of artworks (such as representational content and compositional relations) which can be transmitted by photographs and to neglect those which cannot. Such approaches are not only fostered by research practices that have come to depend more and more on photographs, they are also well

suited to a readership that is often wholly dependent on photographs for its knowledge of the works discussed. The reader typically understands the critic's text in the light of an accompanying reproduction. And through the process of replacement described above, it is the *reproduction* that the reader expects the text to illuminate; at least, it is only with respect to the reproduction that most readers will be able to judge the text. To discuss things not knowable through the reproduction, or to discuss things that appear to be contrary to what the reproduction shows, seems self-defeating.

This concentration, in writing on art, on the aspects of paintings that are reproducible can lead to a skewed understanding of what paintings are about, and a skewed valuation of various movements and works can result. Our dependence on reproductions favors art that reproduces well or that exists primarily through documentation. Art that depends heavily on nonreproducible properties cannot be successfully understood through photographs, and its influence is thus curtailed.

With respect to contemporary art, not only does the use of photographic reproductions influence our understanding, it also plays an active and direct role in determining what is seen and what is made. The widespread use of photographs and slides to select artworks for exhibitions and awards almost ensures that photogenic work will be selected and supported over nonphotogenic work. For many professional purposes, the way a painting looks in a photograph is now more important than the way it looks in person. In this way, photography not only conditions how we view paintings; it also is shaping the world of painting. The dependence of the art world on photographs means that contemporary artists cannot avoid thinking about how their work will look in reproduction, even if they resist letting such considerations influence their art.

Many of the modern movements in the visual arts can be understood as a response to the prominence of photography and the prevalence of reproduction. On the one hand, abstract expressionism, color field painting, and minimalism can be seen, at least in part, as attempts to emphasize the features (such as size, color, surface, and "objectness") that differentiate painting from photography and as attempts to frustrate photographic reproduction. They can be seen as efforts to defy photography's encroachment on painting's territory and to obstruct photography's appropriation of paintings through reproduction.

On the other hand, movements such as photo-realism, pop art, and conceptual art embrace photography and reproduction: photo-realism, by adopting the look of the photograph; pop art, by celebrating reproducibility, the multiple image, and the mass-market consumer product; and conceptual art, by abandoning aesthetic properties in favor of verbally or photographically transmittable ideas.

If we turn to more contemporary art, we see work that does more than simply embrace reproducibility. Sherrie Levine, Cindy Sherman, and Barbara Kruger create works that are about reproduction and about the recontextualization celebrated by Berger. Even though their works use images, the message is conceptual. Artists who de-emphasize the importance of aesthetic features while emphasizing the conceptual are accommodating an art world where photographic, and now digital, transmittability is everything.

The notion of an original may no longer be relevant to a wide range of contemporary work that embraces reproducibility. Nevertheless, for an even wider range of work, past and present, an acquaintance with the original is necessary for an adequate understanding of the artwork and for an appreciation of its richness and complexity. The unique value of the original is not imperiled by photo-

graphic reproduction. What is imperiled, in a world increasingly dependent on reproductions and facsimiles, are our attention and sensitivity to such value.

The Usefulness of Reproductions

It may seem inconsistent to decry the reliance on reproductions and argue for their tendency to mislead while using reproductions throughout this book. But there is no inconsistency, since I have not argued against the use of photographic reproductions. To the contrary, I recognize that reproductions serve an extremely important function, showing us works that would otherwise be inaccessible, allowing us to follow critical discussions that would otherwise be difficult to comprehend. Nevertheless, reproductions are limited in what they can show us and can even be misleading. This does not mean that we should do away with reproductions; it does, however, mean that we should use them in ways that are critically informed.

It may be useful to compare reproductions with translations from one language to another. We depend on translations to know the richly varied literature of the world, but we could never expect a translation to somehow fully capture the original. Translations always capture some aspects of a work at the expense of others; they always involve some sort of modification, if only of sound. It would be folly to judge an author's use of language solely on our knowlege of his or her work in translation, just as it would be folly to judge a painting by its reproduction. Reproductions, like translations, are tools that can be used carelessly or wisely. To use them wisely, we must keep in mind their limitations.

The reproductions in this book are a case in point. They are provided to facili-

tate an understanding of the book's argument, but at the same time they have the potential to undermine that argument, since they tend to make paintings and photographs look more alike than they really are. Reproductions can at most allude to the differences we encounter in looking at paintings and photographs in person. It is only by drawing on our experiences of such encounters that we are able to use reproductions wisely, to facilitate rather than obscure our understanding of those differences.

5 | Transforming Media

Painting, Photography, and Digital Imagery

The conventions of viewing and interpretation that shape our experiences are at least in part based on the beliefs and practices of a community, so we should not be surprised to find that the conventions of both painting and photography change significantly over time, and change in response to new technologies. In this book, I have given an account of how our experiences of photographs and paintings diverge; however, this account is tied to a particular age and set of circumstances. In fact, the relations between these two media have undergone important changes, from the time of photography's first struggle to define itself against painting, to the present time, when with the help of digital technology,

185

photography again finds itself moving closer to painting. It is with the impact of this new technology that this chapter is primarily concerned.

Technological Advancement and the Resources of Art

The materials and tools employed by artists help to shape the character of their art; it is difficult to imagine Rembrandt painting with tempera instead of oils, or Cartier-Bresson taking his photographs without a hand-held camera. For this reason, any innovation in materials and tools, any technological advances, would seem to expand the resources of art, providing artists with more possibilities to choose from, more ways of creating.

But the relation between technological advancement and artistic resources may not be quite this simple, because technology may not be simply additive in its effects. Patrick Maynard discusses this issue in his paper "Photo-opportunity: Photography as Technology." Maynard describes how technologies can generally be understood as amplifiers of our powers of locomotion, of communication, or of production, among others, but he points out that while a given technology will amplify certain of our powers, it will, typically, suppress others. "A fork-lift tractor greatly increases our already existing powers to lift and move loads . . . but a fork-lift does so by losing, even suppressing, the abilities that hand workers have to sense—not only weight but load, strain, density and frictional hold between surfaces."[1] Maynard describes photography as a technology that enhances our powers of depiction and detection, and he calls on us to investigate the suppressions to which photography may be subject.

It is my contention here that not only does any particular technology, such as

photography, have its own amplifications and suppressions in the manner discussed by Maynard, but that such a new technology introduced into the realm of art can affect the whole field of choices available to the artist, widening it in one area only to narrow it in another. New technologies alter, rather than simply extend, the resources of art.

This needs some explanation. With the introduction of fork-lifts, the use of manual lifting is not abolished; it can still be used in those cases where the disadvantages of the suppressions associated with fork-lifts outweigh their advantages. The fork-lift simply adds to the possible ways we might choose to lift things. There is also a sense in which a new technology of art simply adds. By the mid-nineteenth century, an artist interested in creating an image could not only choose from among charcoal, ink wash, watercolor, oil paint, etching, and other media available to previous generations, he or she could also choose to make a daguerreotype or a calotype, something that would not have been possible decades earlier.

But the resources of art are not simply physical materials and processes. Each process comes with beliefs, practices, and conventions that affect our understanding and reading of the images produced and that the artist employs to achieve his or her desired effects. The development of a new medium can change the way we see and use older media, and can thus change our readings of works produced in those older media. Once beliefs and practices have altered, artists may find that certain types of effects can no longer be obtained.

To illustrate this point, I will look at one of the most recent developments in the technologies of art, that of digital imagery and its application to photography. I will show that while the technologies of digital imagery are expanding certain resources of photography, they are also bringing with them an altered atti-

tude that may ultimately diminish some of the powers to which photography traditionally laid claim.

Photography and the Conventions of Painting

Before we consider the effects of digital imagery on photography, we must understand how photography functioned before this new technology was introduced. More specifically, we must look at the features that have distinguished photography's use in the production of images. Toward this end, it is helpful to consider the ways in which photography has functioned differently from painting.

One of the motives contributing to the development of photography was the desire for a technology that would allow a person, even one with little talent for drawing, to capture on paper what he or she saw. What developed was not just an aid to drawing, but a whole new medium, one that introduced a new range of possibilities to the artists who ventured to use it.

Initially these new possibilities were not always appreciated or exploited by those who sought to use photography to make art. Some photographers, such as Oscar Rejlander and Henry Peach Robinson, attempted to model their photographs on paintings. They chose themes characteristic of academic painting, creating allegories and illustrations, and they achieved a painterly look, using soft focus and carefully posed compositions. These compositions were sometimes planned in sketches and accomplished through the use of composite printing. Rejlander's *Two Ways of Life* is a famous example that required the combination of thirty negatives to create a picture contrasting the path of virtue

with that of vice. (Later champions of painterly photographs, such as Robert Demachy and Gertrude Kasebier, eschewed composite printing, but used coarse papers and the gum bichromate process to achieve a painterly surface.) But there were other photographers in this early period, such as Peter Henry Emerson and Frederick Evans, who saw photography as an independent art, one whose distinctive character must be respected. Photographers who embraced the medium's distinctive features and who began to highlight its special immediacy, vividness, and look, as well as the rather peculiar ontological status of its images, gradually became accepted as artists. In the process, they helped to change the look of all art.

Photography extended the conventions of art by exploring new pictorial approaches, especially with regard to composition. For example, since the Renaissance, if not earlier, we had come to expect in Western art a carefully balanced picture, one often built around a central point of importance. Photography, with its instantaneous capturing of a world in flux and the relatively casual usage permitted by the small hand-held camera, accustomed us to a sometimes asymmetric, sometimes cropped image whose edges might be of more visual importance than its center.

Photography also encouraged a new approach to depiction. Paintings traditionally showed things from characteristic or familiar angles, making objects and people readily identifiable, while photography lent itself to the exploration of the uncharacteristic aspects of things. The bird's eye view, the worm's eye view, and the extreme closeup showed us objects as we had never seen them before.[2]

Photography also challenged what was acceptable in a picture. Whereas even realistic paintings tended to aestheticize or "idealize" (of course, there are notable exceptions), photography showed people and places in unforgiving exact-

ness and detail—the squalor of a slum, the traces of hunger and disease on a face. In addition, photography lent itself to the examination of the mundane—a deserted city street, the interior of a factory, the side of a barn.

Whether photography introduced these new approaches or only furthered their rapid development is open to debate. As described by Heinrich Schwarz and, later, by Peter Galassi, some paintings and sketches of the late eighteenth and early nineteenth centuries seemed to anticipate photographic techniques.[3] This was especially true of the 1820s and 1830s, the decades of photography's first primitive stages. For example, John Constable's oil sketch *Cloud Study, Hampstead* (1821) shows us a fragment of sky, and in the lower right corner, the tips of trees. The cropping and framing of the composition are highly unconventional, and the subject matter is unsuitably trivial by traditional norms of painting. Christen Købke's *View at Dosseringen* (c. 1837) depicts a landscape dominated by what appears to be a clump of weeds in the foreground. Not only is the subject matter commonplace, but the point of view is novel by conventional standards of painting, for the proximity of the weeds and their placement near eye level make them tower in front of the trees and the mill in the distance. Johann Erdmann Hummel's *Polishing of the Granite Bowl* (1831) not only focuses on the mundane, the manufacture of a granite basin, but does so with a "photographic" precision.

It is not clear whether this apparent anticipation of the practices of photography by these and many other works was the result of the increased use of those drawing aids that were the precursors to photography—the camera obscura and the camera lucida—or whether it resulted from a nascent change in attitude toward representation which itself made the time ripe for the invention of photography. But whether or not photography and its technological predecessors initi-

John Constable

Cloud Study, Hampstead, 1821. Oil on paper laid on board, red ground, 24.1 × 29.9 cm. © Royal Academy of Arts, London.

Johann Erdmann Hummel

The Polishing of the Granite Bowl, 1831. Oil on paper, 46 × 75 cm. Staatliche Museen zu Berlin, Preussischer Kulturbesitz Alte Nationalgalerie, Berlin.

ated these new practices, photography was particularly suited to them and became primarily responsible for their rapid development and widespread influence.

Photography contributed to a new way of seeing that revolutionized the look of paintings, as painters came to be influenced by photographs and even began to use them as source material. For example, Manet's *Gare St. Lazare* and Toulouse-Lautrec's *A la Mie* were both based on photographs, making them early examples of a relatively common practice that has continued to this day.

There are many things that photography brought to the repertoire of image-making processes: a rapidity and ease of production, a new standard of precision and accuracy, a more informal and experimental approach to composition and subject matter. But perhaps most distinctive was the perceived status of the photographic image, a status derived from the mechanical nature of its production. The photograph is seen as having a special connection with reality and an independence of the photographer's intentions.

We have already seen that this perception of a special connection with reality has to do with the way photographs are typically made; it does not rest on the exact duplication of appearances. Even a blurred and indistinct photograph is seen as having this special link, and as having a documentary value unavailable to painting. Nevertheless, we tend to conflate the separate concerns of documenting and duplicating when we look at photographs, and this conflation allows our faith in the documentary character of the photograph to be inappropriately transferred to the way things appear within the photograph. When this occurs, we believe not only that a photograph gives evidence of an object's existence, but also that it shows us how that object really looks.

This way in which photography has appropriated for itself the mantle of realism is perhaps the most important way it has changed our view of painting. Before photography, painting developed its own notions of realistic depiction that differed from age to age, region to region. The finely detailed renderings of da Vinci differed in their realism from the more "impressionistic," but more spatially suggestive, shadows and brushwork of Rembrandt. Realism was able to take many painterly forms, but the intrusion of photography has changed all that. Our confidence in the documentary nature of photography has made it difficult, if not impossible, to see painting as realistic on its own terms. Even though paintings and drawings can be superior means of conveying information (drawings are used instead of photographs in many birding books) and superior means of recording how we see (they are not governed by the perspectival distortions of photography), painting has had to adopt the look of photography to appear realistic, to appear faithful to the subjects it depicts.

Because of its aura of objectivity and mechanical precision, the photograph has become the standard against which we measure the realism of all other images. It is this, I believe, rather than photography's superior accuracy, that contributed to painting's dwindling interest in the goal of realistic depiction, as the nineteenth century drew to a close. (It is interesting to note that when realism in painting made a strong comeback in the mid-twentieth century, it was as photorealism.)

As we have seen, the faith in the realism of the photograph plays an important role in its aesthetic impact, for it affects the way we respond to photographic transformations, such as the defamiliarization caused by cropping in *Leaf Pattern*, the spatial disjunctions caused by framing and vantage point in *Valencia*, or the matching of movements allowed by the freezing of motion in *Behind the*

Gare St. Lazare. Because we think of photographs as showing us how things "really" look, their transformations have a compelling force and surreal power that those of painting lack. But this faith in the realism of the photograph does not simply affect how we respond to photographic transformations, it permeates our response to everything in the photograph—the harmonious interplay of elements, the poignant gesture, the telling juxtaposition—and accounts for our divergent readings of pictorially similar paintings and photographs.

Our faith in the realism of photography is based on our beliefs about the way photographs are typically produced. The development of digital technology, along with the increasingly common practice of digitally altering photographs, threatens to undermine our faith in this realism and to radically alter the way in which we see photographs.

The Impact of Digital Technology

A digital image is made up of a grid of discrete units known as pixels. With numbers used to specify the color or shade of each pixel, the image can be electronically stored, copied, transmitted, displayed, and printed. It can also be altered in innumerable ways.

The interaction between digital imagery and photography is made possible by the fact that ordinary photographs can be scanned and converted to digital format. The smooth curves and tonal gradations of the photograph are converted into the discrete steps of a grid. More directly, digital cameras can be used to capture images from the world electronically on disk, bypassing the photochemical process. Once an image is in digital form, its components can be re-

arranged, extended, deleted, and in other ways modified before it is printed—processes made all the easier by software designed expressly for these purposes. When we add to the enhanced ease and power of alteration the possibility of simulating photographically realistic components on computer, it appears that the "photographer" has gained complete control over the image and has acquired the freedom of the painter to depict whatever he or she can imagine.

The digital product of this new creative freedom, however, is no longer a photograph. This is argued by William Mitchell, who maintains that digital images are as different from photographs as photographs are from paintings.[4] He explains how the fundamental distinction between the continuous gradations of the analog image and the discrete steps of the digital image generates differences with respect to the processes of enlargement and reproduction. With their continuous spatial and tonal variations, photographs can be indefinitely enlarged to reveal greater detail; their resolution degrades only gradually with this enlargement. Digital images, however, have a precisely limited resolution; enlargement beyond the point where they reveal their component grids can yield no new information. The discrete components of a digital image do, on the other hand, allow for exact reproduction, so the copy of a digital image can be indistinguishable from its original. Not so for the photograph. Its subtle gradations cannot be exactly reproduced, so the photograph of a photograph will never have the precision of the original. But perhaps the most significant difference between the two types of image is to be found in their divergent susceptibility to alteration. This divergence is significant, because it is the digital image's enhanced alterability that precludes it from ever having the credibility attributed to photographs.

A convincing photographic alteration requires the skillful and painstaking manipulation of fragile surfaces. Digital images, however, can be electronically

altered with relative speed and ease. The range of digital alteration also greatly
exceeds that of conventional photographic alteration. Elements can be reshaped,
repositioned, or removed at will. Images from different sources can be freely
combined and blended. With digital alteration, faces can be aged or the features
of several faces can be merged, as in the work of Nancy Burson. Furthermore,
digital alteration can be done seamlessly, making it difficult, if not impossible,
to detect. (This undetectability, however, is often greatly overestimated. Without
careful matching of tone, lighting, scale, and perspective, a digital alteration will
not be undetectable.)

The relative ease, freedom, and undetectability of digital manipulation make it
hard to resist—and commonly employed. Whereas alteration is the exception
for traditional photography, alterability and manipulability can be seen as defin-
ing characteristics of digital imagery. According to Mitchell, "Computational
tools for transforming, combining, altering, and analyzing images are as essen-
tial to the digital artist as brushes and pigments are to a painter, and an under-
standing of them is the foundation of the craft of digital imaging."[5]

Indeed, it is already possible to see an increased tendency toward the alter-
ation of images accompanying the increased digitization of photojournalism.
Fred Ritchin provides many examples of such alteration in his book *In Our Own
Image.* He describes how the elements of a photograph can be repositioned, as
in *National Geographic*'s much-discussed 1982 cover image of the pyramids of
Giza. The pyramids were digitally pushed closer together so that the image
would fit the magazine's vertical format. He describes how the elements of a
photograph can be deleted, as in *Rolling Stone*'s 1985 cover shot of Don Johnson,
in which Johnson's shoulder holster and pistol were digitally removed for a less
violent image. And he explains how elements from different photographs can be

Nancy Burson

Warhead I. Computer-generated composite portrait of the leaders of the world's nuclear nations, c. 1982. © 1982 Nancy Burson with Richard Carling and David Kramlich.

combined in a new image, as in *Newsweek*'s combination of separate photographs of Dustin Hoffman and Tom Cruise to form what appears to be a photograph of the two actors in each other's company.[6]

Ritchin goes on to argue that this new technology must ultimately change the way we use photographs in the mass media. As it becomes more common to digitize photographs and to use digital cameras, and as it becomes easier to alter these digital images to reflect whatever scenarios we might dream up, the documentary usefulness of news and feature photographs is severely diminished.

With the ease of digital manipulation, alteration is becoming more widespread; with its relative seamlessness, digital alteration is harder to detect than previously available cut-and-paste methods; and with the use of digital cameras, there is no negative against which an image can be checked for tampering. There is not necessarily anything about the digitally altered image to alert us to the fact that there has been manipulation, and in a world where manipulation is on the rise, all images encountered in the media, even reproduced photographs, become suspect. This is because we cannot necessarily tell whether the relatively coarse image in a newspaper or magazine is reproduced from a photograph or whether it is reproduced from a digital, and possibly altered, image.

Of course, there will always be some images whose altered or tampered status will be obvious, either because of technical glitches or because the scene shown is known to be utterly impossible. But when we look at a reproduction of what seems to be a straight photograph, it will become more and more difficult to be confident that no manipulation has taken place.

Photojournalism is not the only area prone to this growing skepticism. We may find ourselves viewing all reproduced photographs—the advertisement in a magazine, the textbook illustration, the duotone plate in a book of pho-

tographs—with increased uncertainty. But more significantly, we may find our skepticism extended to our firsthand encounters with photographs. We have always had reason to view photographs with some skepticism, for they have always had the potential to mislead us. Not only elaborate techniques such as retouching and combination printing, but also simple methods such as cropping and labeling can radically alter our perception of a photographed event. Ritchin cites the example of a *Washington Star* story that was illustrated with a photograph of Ted Kennedy leaving a Kennedy Center gala.[7] In the first edition, the photograph was cropped in such a way that Kennedy appeared to be walking in the company of a young woman. The whole picture, however, shows Kennedy walking with a priest on his left, while the young woman walks behind, in the company of another man. Although this example is taken from a newspaper, it does not depend on the concealments of reproduction for its impact. The deceptions perpetrated by cropping are equally effective in the firsthand viewing of a photograph.

Mitchell also discusses how photographs can be used to mislead, and cites the example of Alexander Gardner's photographs of a dead Civil War soldier.[8] *Fallen Sharpshooter* shows a dead Union soldier, but the same body was moved and rephotographed as *Slain Rebel Sharpshooter.*

Photographs have always had the potential to mislead, but there have also always been limits to this potential. For instance, with the Gardner photographs, we can be reasonably sure that there was a man, seemingly dead, lying in front of the camera. With the cropped photograph, we can reasonably assume—given the difficulties of creating a truly convincing photographic montage—that Kennedy and the young woman were, at some point, in the same vicinity. If we allow for the possibility of digital manipulation, however, no such assumptions

are safe. It becomes plausible that the figures of Kennedy and the woman came from different photographs; it becomes possible that the dead soldier is no one historical individual but a composite figure formed by combining the images of several slain soldiers. To the extent that we can see photographs as potentially indistinguishable from their digitally altered counterparts, they become suspect as carriers of even the most basic information, suspect as bearers of any evidence.

This destruction of photographic credibility does not necessarily await the widespread availability of photographically printed digital images that actually do approximate the fine resolution and depth of original photographs. Even if it always remains possible to distinguish between an original photograph and a digital image, we may find ourselves coming to view photographs differently. This is because the more we encounter reproductions of photographs that have been digitized and altered—in newspapers, magazines, advertisements, and elsewhere—the more we will think of photographs as manipulable. The expectations formed in these everyday encounters with reproductions may come to condition our less frequent firsthand experiences with photographs, and we may find ourselves increasingly ready to entertain the possibility that a photograph has been altered.

Our implicit faith in the veracity of the photographic image is deeply ingrained, so it would take much more than a few digital forgeries to reshape our habits of seeing. After all, old-fashioned photographic forgeries have always been plentiful, as in the composites of supermarket tabloids and as in retouched high school yearbook photographs. But alongside these conventionally altered images, there has always been a much larger mass of photographs that were straight, some taken by journalists and other professionals, but many more

taken by ordinary folks who send their exposed film to commercial developing labs. Digital scanners and cameras, however, are now putting manipulation techniques at the fingertips of anyone with the appropriate software and a relatively modest amount of hardware, equipment that becomes more and more widely available. Just as computers have made it much easier to revise papers (there is no laborious retyping of a whole manuscript to go through and no messy traces of cutting and pasting), computers make it easier to "revise" a photograph. And when something is easier to do, people do it with more frequency and less thought. One can easily imagine the vain routinely doctoring their photographs to take a few inches off their waists and add a few hairs to their heads. Or one can imagine the newly divorced methodically deleting ex-spouses from their family pictures. (In fact, companies providing such services for the divorced already exist.)

If we reach a point where photographs are as commonly digitized and altered as not, our faith in the credibility of photographs will inevitably, if slowly and painfully, weaken, and one of the major differences in our conceptions of paintings and photographs could all but disappear.

The Aesthetic Implications of Digital Technology

This change in the credibility of photographs not only would affect our ability to use photographs as evidence; it could also have far-reaching implications for the aesthetics of photography. Most discussions of the computer's effects on art photography have emphasized the new opportunities afforded. The freedom of painting is wedded to the realism of photography, allowing the digital artist to

modify a photograph to fulfill his or her creative vision. But this new freedom may be bought at the cost of photography's power, or at least of one source of its power—that which derives from the photograph's perceived special connection with the world. With the loss of this perceived connection, photography's special surreal fascination may be lost.

Consider a photograph made by Margaret Bourke-White, *Louisville Flood Victims* (1937), which shows a group of people waiting solemnly in a bread line. Behind the bread line, filling almost the entire background of the photograph, stands a large billboard that depicts, under the banner "World's Highest Standard of Living," a cheerful middle-class family out for a ride in their sedan, father and mother in the front seat, two children and a dog in the back. To the right side is the text "There's no way like the American Way." The size of the billboard overpowers the bread line, and the car with its oblivious occupants seems about to run over the people waiting in line.[9] The ironic contrast between the self-congratulatory message of the billboard and the needy circumstances of the people waiting for food is augmented by a contrast of race: the family in the car is white, the people in the bread line are black.

This smug, or naive, billboard lent itself to ironic juxtapositions all over the American landscape of the 1930s; the same billboard can be found in an Arthur Rothstein photograph from 1937, proclaiming its message of prosperity amid the decaying buildings of Birmingham, Alabama.

Both Bourke-White's and Rothstein's photographs provide a powerful commentary on the gap between government propoganda and depression-era reality, between middle-class and underclass. They bear powerful witness to the destitution to be found in the country with the "world's highest standard of living."

A similar irony can be found in an image made over fifty years later by Mexi-

Margaret Bourke-White

Louisville Flood Victims, 1937. Margaret Bourke-White, *LIFE* Magazine © TIME INC.

Pedro Meyer

Mexican Migrant Workers, Highway in California, 1986/90. Digitally altered photograph.
© Pedro Meyer.

can photographer Pedro Meyer. In *Mexican Migrant Workers, Highway in California* (1986/90), a billboard, whose structure is labeled "Reagan," is set in a field of migrant workers bending over their crops. The billboard advertises "free luxury service from your motel" to Ceasars, and shows a Roman soldier holding open the door to a van. The message seems cruelly out of place. These migrant workers were probably brought to their field by a pickup truck, not a luxury van, and they are offered back-breaking work, not luxury service. The Roman soldier is not there to serve them; instead, he looks like he is there to oversee their labor. There is irony here as there is in the images of Rothstein and Bourke-White.

Meyer's image, however, is a montage, a digital combination of two separate photographs. These migrant workers never picked crops in front of that billboard; the ironic juxtaposition was created by Meyer. It is an irony of two images artificially brought together, not one of two things actually found together. It is an irony of idea, not one of circumstance. For this reason, the impact of Meyer's image is not quite the same as that of the Bourke-White or Rothstein photographs.

One thing that moves us in looking at the Bourke-White and Rothstein photographs is our knowledge that such a billboard would be placed near a food distribution center or near an area of urban decay. The photographs reveal the callousness or cruel ignorance of the self-congratulatory message, but they do so without seeming polemical, for they simply record what was there to be seen. Once montage, digital or otherwise, is used to create such juxtapositions, the irony becomes more abstract and less penetrating.

Meyer sees the use of the computer as a way of overcoming the limitations of straight photography and of expanding the expressive potential of his work. Not only can digitization be used to create ironic juxtapositions, it can also be used

to re-create a lost moment or to supply the pithy image that real life has failed to provide. For instance, Meyer describes how the photograph he took for *Desert Shower* (1985/93) failed to capture a formation of warplanes that had flown overhead. With digital technology, he was able to restore the picture to match his memory of a missed opportunity; he was able to recreate the lost moment by adding warplanes to the picture. Discussing another work, *Contestant #3* (1991/93), Meyer describes how he combined two photographs of a beauty contest. He explains that he wanted to show the striking dignity of a contestant who was noticeably overweight in comparison with her rivals, but that none of the photographs he had taken contained the juxtapositions he needed. "The specific 'decisive moment' wasn't to be found, it had to be created" through digital manipulation.[10]

Meyer's choice of words is rather jarring, since "the decisive moment" is so closely tied to the idea of perfect timing. The phrase conjures a fleeting moment of visual significance synchronically recognized and captured, not a lost moment reconstructed or an ideal moment invented. A digitally altered image can seem to capture the decisive moment only insofar as it is able to trade on the documentary aura of straight photographs. But the more widespread and sophisticated digital alteration becomes, the less this will be possible—even for straight photographs.

Consider once again Cartier-Bresson's *Behind the Gare St. Lazare*. The photograph has the potential to mislead as a putative documentary image; for instance, the leap might have been staged or the location misidentified. Nevertheless, on the basis of this photograph few of us would hesitate to say that leaping man, puddle, ladder, and posters existed, if only for an instant, in proximity to one another. Although it is perhaps possible to imagine that the photograph was

created as a combination print, in the absence of any provocation to do so, we do not feel compelled to entertain this possibility. However, in an age where digital technology is widely used to create and alter images, we may come to view such a work differently. If we introduced the possibility of digital manipulation, we would not be so ready to assume that the posters bordered the puddle or that the man attempted to leap it. We would not be so ready to dismiss the possibility that posters and man, along with their respective reflections, were electronically added to the image from other photographs—or from the photographer's imagination, insofar as these elements of the image could be digitally simulated. Instead of the photograph being a happy confluence of reflected leaping figures caught at the decisive moment by the photographer, the possibility of digital manipulation would make the work seem much more contrived, and I believe it would give us less delight, or at least a delight of a different kind.

Valencia would also suffer if it were seen against a background of widespread digital manipulation. Part of what fascinates us about this photograph is the way that vantage point and framing can lead to such a startling image. If, however, we entertain the possibility of digital montage, if we no longer assume that the composition shows a unified space, it becomes considerably less intriguing.

The potential threat to photography does not rest here. If *Behind the Gare St. Lazare* were a painting, it would be of only anecdotal or historical interest whether the composition derived from a real event or was invented by the artist. If *Valencia* were a painting, it would make little difference to its aesthetic value whether its composition corresponded to an actual vantage point or was fabricated by the artist. Even when it does happen to correspond to an event or a view found in the world, a painting is essentially seen as a construction. With the rising prevalence of digital manipulation, photography may be heading in the

same direction. When we encounter what looks to be a photograph, we may be increasingly likely to view it as a construction.

Our changing expectations for photographs could affect even the way we view the photographs of the past, those made long before the advent of digital technology—or at least the way future generations look at such photographs. Those of us who started looking at photographs before the digital revolution will probably still retain, at least in part, our habitual ways of looking at works by Cartier-Bresson and others. But those who grow up in an age where the photographic image is seen as fluid and manipulable may have trouble appreciating the aura of evidential authority surrounding traditional photographs.

Will future generations come to see the transformations of traditional photography—the apparent disjunctions of space, the defamiliarization of ordinary objects, the fortuitously frozen moments—as constructions of the photographer, rather than as revealing something uncanny about our world? It is impossible to know for certain, but changes in the expectations surrounding photographs could very well lead to such changes in the way future viewers see all photographs, altering the kind of pleasure, and the kind of pain, that photographs give.

Photographs have always served our desire to understand the past, preserving for our view people, places, and ways of life that have long since vanished. Perhaps the "classic" period of photography, the first one hundred and fifty years or so when we were able to see photographs as revelatory of the world, will soon itself become lost to our experience and understanding.

Postscript | # Past and Present

There has recently been some resurgence of interest in daguerreotypy and other older processes. Not only have there been several exhibitions of vintage daguerreotypes, at the Getty Museum and elsewhere, but more and more contemporary photographers are exploring these "obsolete" forms.[1] In this return to tintypes, albumen prints, and daguerreotypes, there is a return to photography's body, a movement toward images whose material substances assert themselves and away from digital disembodiment. The daguerreotype is especially notable in this regard. The singular image in its velvet-lined case is in many ways the antithesis of the digital image.

The interest in daguerreotypy is quite understandable. Even today, the daguerreotype is striking in its ability to capture an image of breathtaking detail and depth; however, with a tilt of the head or a slight movement of the hand, this image disappears into the brightness of its mirrored surface or is effaced by the reflections in its silvered depths. The daguerreotype's lifelike image is shown to be mere traces on a metal plate; nevertheless, when the appropriate angle of viewing is reestablished, so too is the daguerreotype's magical hold.

The powerful yet tenuous nature of the daguerreotype's image perhaps expresses the paradox of photography better than anything else. No matter how constantly we are reminded of the photograph's image status, we are seduced again and again by its lifelike hold. No image conjures the past as effectively as a daguerreotype, but perhaps no image serves as a better metaphor for the present, for the alternating visions of photography that surface, hover delicately, and dissolve, as we pursue them.

Notes

1. Ambiguous Images

1. E. H. Gombrich, *Art and Illusion* (Princeton: Princeton University Press, 1960), p. III. Gombrich refers the reader to Ernst Kris and Otto Kurz, *Die Legende vom Kunstler* (Vienna, 1934). For a thorough discussion of such legends, see David Freedberg, *The Power of Images: Studies in the History and Theory of Response* (Chicago: Chicago University Press, 1989).

2. Arthur K. Wheelock Jr., *Jan Vermeer* (New York: Abrams, 1981), p. 106.

3. Paul Phillipot, "Les Grisailles et les 'degrés de réalité' de l'image dans la peinture flamande des XVe et XVIe siècles," *Musées Royaux des Beaux-Arts Bulletin*, no. 15 (1966), 225–42.

4. Ibid., 232.

5. Freedberg, *The Power of Images*, pp. 310–11, 309, 301, 312.

6. Ibid., p. 307.

7. Theodore Reff, "The Pictures within Cezanne's Pictures," *Arts* (June 1979), 100.

8. Ibid., 103.

9. Actually, this is one woman, painted in three different poses.

10. Alain Madeleine-Perdrillat, *Seurat* (New York: Rizzoli, 1990), p. 99.

11. This is quite different from Oscar Wilde's *Picture of Dorian Grey*, for in that story the man does not become a picture; man and picture, however, do trade attributes. The man acquires the picture's immutability, and the picture, the aging process of the man.

2. Transformation in Photography

1. Daguerre quoted in Susan Sontag, *On Photography* (New York: Farrar, Straus & Giroux, 1973), p. 188; Roland Barthes, *Camera Lucida: Reflections on Photography*, trans. R. Howard (New York: Hill & Wang, 1981), p. 80.

2. Rudolf Arnheim, "On the Nature of Photography," *Critical Inquiry* 1 (September 1974), 155, 154.

3. Joel Snyder and Neil Walsh Allen, "Photography, Vision, and Representation," *Critical Inquiry* 2 (Autumn 1975), 143–69.

4. Throughout this book, I speak of the way in which photographs transform objects. By this, I just mean that the appearance of an object in a photograph is different from its appearance in real life. Even so, I will be arguing that there is a sense in which we *think* of the object itself as changed when we look at its photograph.

5. There may not even be a contradiction in claiming that photographs really do have a documentary power despite the photograph's deviance and the photographer's creative control. See discussion on pp. 87–88.

6. Laughlin writes about this photograph: "A horrible little stucco figure, probably

turned out by thousands in a mold, and found in a Louisiana country garden. The fierce suns and heavy rains of Louisiana have eaten it as though by acid—leaving it as though with its brain exposed, and with a smile turned sickly and defeated." *Clarence John Laughlin: The Personal Eye* (New York: Aperture, 1973), p. 116.

7. These last two points owe much to Rudolf Arnheim's *Film as Art* (Berkeley: University of California Press, 1957) and to Bela Balazs's *Theory of the Film: Character and Growth of a New Art*, trans. E. Bone (1953; New York: Dover, 1970).

8. Stephen de Pietri and Melissa Leventon, *New Look to Now: French Haute Couture, 1947–87* (New York: Rizzoli, 1989).

9. For two striking examples of this, see André Malraux's *Voices of Silence*, trans. Stuart Gilbert (1953; Princeton: Princeton University Press, 1978), pp. 27–29.

10. In this discussion of Magritte, I rely heavily on Michel Foucault's analysis in *This Is Not a Pipe*, trans. James Harkness (Berkeley: University of California Press, 1983).

11. Kendall Walton, "Transparent Pictures: On the Nature of Photographic Realism," *Critical Inquiry* 11 (December 1984), 246–77; the examples are discussed on pp. 246–47. My discussion in this section owes much to Walton's paper.

12. Walton illustrates this point by juxtaposing a Goya etching from *The Disasters of War* with a Timothy H. Sullivan Civil War photograph (p. 248).

13. Ibid., pp. 251–53.

14. In other words, I only contend that photographs are *seen* as transparent. This weaker claim is sufficient for my present purposes.

15. Of course, the perceived objectivity of the photographic process is compatible with the acknowledgment of the subjectivity of the selection of subject matter and point of view.

16. One might think that the metal snaps attached to *The End of Contemplation* could serve this animating function. But in reproduction, the snaps tend to seem a part of the painted surface.

17. André Bazin, "The Ontology of the Photographic Image," in *What Is Cinema?*,

ed. and trans. Hugh Gray (Berkeley: University of California Press, 1967). Arnheim, "On the Nature of Photography," p. 155.

18. Beaumont Newhall discusses this problem in *The History of Photography* (New York: Museum of Modern Art, 1982), pp. 73–74.

19. It should be noted that in many of Laughlin's "straight" photographs, objects *are* perceptually transformed. For example, both the decaying statue in *Our Festering Hands Ruin All* . . . (1951) and the gnarled wood "hand" in *The Appearance of Anonymous Man* (1948) achieve animation.

3. Transformation in Film

1. Actually, I am not altogether convinced that the newspaper photograph used by the film does, in fact, show the mannequin rather than Ginger Rogers. The effect, however, would be much the same in either case—which supports my point.

2. Discussed by Béla Balázs in *Theory of the Film: Character and Growth of a New Art*, trans. E. Bone (New York: Dover, 1970) and by Rudolf Arnheim in *Film as Art* (Berkeley: University of California Press, 1957).

3. This term was first suggested to me by Tom Leddy.

4. For further discussion of the complexities of this sequence, see Mary Ann Doane, "*Caught* and *Rebecca*: The Inscription of Femininity as Absence," in *Feminism and Film Theory* ed. Constance Penley (New York: Routledge, Chapman and Hall, 1988), pp. 196–215.

5. I here depart from common usage and classify as animated films only those films which rely on drawn images. Films using stop-action photography are discussed in the next section, Special Effects.

6. Erwin Panofsky, "Style and Medium in the Motion Pictures," repr. in *Film Theory and Criticism*, ed. Gerald Mast and Marshall Cohen (New York: Oxford University Press, 1974), pp. 160 (note), 161.

7. The classic Warner Brothers cartoon *Duck Amuck* provides the animated equiva-

lent of this sequence, in which the increasingly infuriated Daffy Duck tries to cope with the constantly changing environments created by the cartoonist's intrusive brush. In this case, however, we find out that Daffy is as malleable as his environment.

4. Photographic Reproduction

1. In André Malraux, *The Voices of Silence*, trans. Stuart Gilbert (1953; Princeton: Princeton University Press, 1978).

2. In Walter Benjamin, *Illuminations*, ed. Hannah Arendt, trans. Harry Zohn (New York: Harcourt, Brace & World, 1968).

3. John Berger, *Ways of Seeing* (London: Penguin, 1972), p. 23.

4. In this chapter, I have not, for the most part, made a distinction between photographs of artworks and the various printed images made from these photographs that appear in books, posters, and other formats. These images are even further removed than the photographs from the original works of art, and their values are often less refined; so my analysis, in what follows, of the ways in which photographic reproductions can mislead holds even more strongly for these derivative images.

5. Susan Lambert, *The Image Multiplied* (New York: Abaris, 1987), p. 16.

6. In fact, according to Lambert, most prints did not aim at exact reproduction. They adapted the designs of paintings to the conventions of prints and served as inexpensive images for the masses. For the most part, these prints were not used to convey information about some absent masterpiece.

7. See Malraux, *Voices of Silence*, p. 30, for his discussion of this example.

8. For an illuminating discussion of the issues surrounding the photographic reproduction of sculptures, see Mary Bergstein, "Lonely Aphrodites: On the Documentary Photography of Sculpture," *Art Bulletin* 74 (September 1992), 475–97.

9. Arthur Danto might have something like this in mind when, in "The Artworld,"

he talks about the impossibility of a radical miniaturization of a Newman. A Newman engraved on a pinhead would become "a blob, disappearing in the reduction." Danto, "The Artworld," *Journal of Philosophy* 61 (October 1964), 574.

10. This point was made by Allen Furbeck, in conversation.

11. On occasion, the absence of a frame can have its advantages, as when the frame is inappropriate for the painting. For example, the color of a frame can interfere with a painting's color relations. This is true of the frames of Matisse's *Seville Still Life* and *Spanish Still Life*, both owned by the Hermitage. The vibrancy of the reds and yellows that predominate in these paintings is drained by the gold tone frames, and for this reason the paintings look much stronger in reproduction.

12. This point was brought to my attention by both Patrick Maynard and Kendall Walton.

13. In Malraux, *Voices of Silence*, p. 25.

14. Ibid., pp. 44–46.

15. Of course, to say that photographs from negatives are multipliable is *not* to say that the various prints from a negative are identical to each other.

16. Charles Tashiro, "Videophilia: What Happens When You Wait for It on Video," *Film Quarterly* 45 (Fall 1991), 8.

17. William J. Mitchell, *The Reconfigured Eye: Visual Truth in the Post-Photographic Era* (Cambridge: MIT Press, 1992), p. 81.

18. Review by John R. Quain, *P.C. Magazine*, September 13, 1994, p. 128.

5. Transforming Media: Painting, Photography, and Digital Imagery

1. Patrick Maynard, "Photo-opportunity: Photography as Technology," *Canadian Review of American Studies* 22 (Winter 1991), 514.

2. Discussed by Rudolf Arnheim, *Film as Art* (Berkeley: University of California Press, 1957).

3. Heinrich Schwarz, *Art and Photography: Forerunners and Influences*, ed. W. Parker

(Chicago: Chicago University Press, 1987); Peter Galassi, *Before Photography: Painting and the Invention of Photography* (New York: Museum of Modern Art, 1981).

4. William J. Mitchell, *The Reconfigured Eye: Visual Truth in the Post-Photographic Era* (Cambridge: MIT Press, 1992), p. 5.

5. Ibid., p. 7.

6. Fred Ritchin, *In Our Own Image: The Coming Revolution in Photography* (New York: Aperture, 1990), pp. 8–18.

7. Ibid., pp. 85–87.

8. Mitchell, *Reconfigured Eye*, pp. 43–45.

9. William Kunstler makes this point in his essay in Marvin Heiferman and Carole Kismaric, eds., *Talking Pictures: People Speak about the Photographs That Speak to Them* (San Francisco: Chronicle Books, 1994), p. 45.

10. Pedro Meyer, *Truths and Fictions: A Journey from Documentary to Digital Photography* (New York: Aperture, 1995), pp. 108–11.

Postscript: Past and Present

1. Lyle Rexer, "Photographers Move Forward into the Past," *New York Times*, September 27, 1998, Arts and Leisure section, pp. 39–40.

Selected
Bibliography

Arnheim, Rudolf. *Film as Art* Berkeley: University of California Press, 1957.

——. "On the Nature of Photography." *Critical Inquiry* 1 September 1974, pp. 149–61.

——. "The Two Authenticities of the Photographic Media." *Journal of Aesthetics and Art Criticism* 53 (Fall 1993), pp. 537–40.

Balázs, Béla. *Theory of the Film: Character and Growth of a New Art.* Trans. E. Bone. 1953. Repr. New York: Dover, 1970.

Barthes, Roland. *Camera Lucida: Reflections on Photography.* Trans. R. Howard. New York: Hill & Wang, 1981.

Bazin, André. *What Is Cinema?* Ed. and trans. Hugh Gray. Berkeley: University of California Press, 1967.

Beck, Jerry, and Will Friedwald. *Looney Tunes and Merrie Melodies: A Complete Illustrated Guide to the Warner Bros. Cartoons.* New York: Henry Holt, 1989.

Benjamin, Walter. *Illuminations.* Ed. Hannah Arendt. Trans. Harry Zohn. New York: Harcourt, Brace & World, 1968.

Berger, John. *About Looking.* New York: Pantheon, 1980.

——. *Ways of Seeing.* London: Penguin, 1972.

Bergstein, Mary. "Lonely Aphrodites: The Documentary Photography of Sculpture." *Art Bulletin* 74 (September 1992), pp. 475–97.

Binkley, Timothy. "The Vitality of Digital Creation." *Journal of Aesthetics and Art Criticism* 55 (Spring 1997), pp. 107–16.

Burgin, Victor, ed. *Thinking Photography.* London: Macmillan, 1982.

Danto, Arthur. *The Transfiguration of the Commonplace.* Cambridge: Harvard University Press, 1981.

Foucault, Michel. *This Is Not a Pipe.* Trans., James Harkness. Berkeley: University of California Press, 1983.

Freedberg, David. *The Power of Images: Studies in the History and Theory of Response.* Chicago: University Press, 1989.

Galassi, Peter. *Before Photography: Painting and the Invention of Photography.* New York: Museum of Modern Art, 1981.

——. *Henri Cartier-Bresson: The Early Work.* New York: Museum of Modern Art, 1987.

Gernsheim, Helmut. *The Origins of Photography.* New York: Thames and Hudson, 1982.

Gombrich, Ernst H. *Art and Illusion.* Princeton: University Press, 1960.

——. *Art, Perception, and Reality.* Ed. Julian Hochberg and Max Black. Baltimore: Johns Hopkins University Press, 1972.

Grundberg, Andy, and Kathleen McCarthy Gauss. *Photography and Art: Interactions since 1946.* New York: Abbeville, 1987.

Kemp, Martin. *The Science of Art.* New Haven: Yale University Press, 1990.

Lambert, Susan. *The Image Multiplied.* New York: Abaris, 1987.

Madeleine-Perdrillat, Alain. *Seurat*. New York: Rizzoli, 1990.

Malraux, André. *The Voices of Silence*. Trans. Stuart Gilbert. 1953 Repr. Princeton: Princeton University Press, 1978.

Maynard, Patrick. *The Engine of Visualization: Thinking through Photography*. Ithaca: Cornell University Press, 1997.

——. "Photo-opportunity: Photography as Technology." *Canadian Review of American Studies* 22 (Winter 1991), 501–28.

——. "The Secular Icon: Photography and the Function of Images." *Journal of Aesthetics and Art Criticism* 42 (Winter 1983), 155–69.

Meyer, Pedro. *Truths and Fictions: A Journey from Documentary to Digital Photography*. New York: Aperture, 1995.

Mitchell, William J. *The Reconfigured Eye: Visual Truth in the Post-Photographic Era*. Cambridge: MIT Press, 1992.

Newhall, Beaumont. *The History of Photography*. New York: Museum of Modern Art, 1982.

Panofsky, Erwin. "Style and Medium in the Moving Pictures." *Critique* 1 January–February 1947); reprinted in *Film Theory and Criticism*, ed. Gerald Mast and Marshall Cohen (New York: Oxford University Press, 1974).

Penley, Constance, ed. *Feminism and Film Theory*. New York: Routledge, Chapman and Hall, 1988.

Phillipot, Paul. "Les Grisailles et les 'degrés de réalité' de l'image dans la peinture flamande des XVe et XVIe siècles," *Musées Royaux des Beaux-Arts Bulletin*, no. 15 (1966), 225–42.

Phillips, Christopher, ed. *Photography in the Modern Era: European Documents and Critical Writings, 1913–1940*. New York: Metropolitan Museum of Art / Aperture, 1989.

Reff, Theodore. "The Pictures within Cézanne's Pictures." *Arts* (June 1979), 90–104.

Ritchin, Fred. *In Our Own Image: The Coming Revolution in Photography*. New York: Aperture, 1990.

Scharf, Aaron. *Art and Photography*. Baltimore: Penguin, 1968.

Schwarz, Heinrich. *Art and Photography: Forerunners and Influences.* Ed. W. Parker. Chicago: Chicago University Press, 1985.

Snyder, Joel, and Neil Walsh Allen. "Photography, Vision, and Representation." *Critical Inquiry* 2 (Autumn 1975), 143–69,

Sontag, Susan. *On Photography.* New York: Farrar, Straus & Giroux, 1973.

Squiers, Carol, ed. *The Critical Image: Essays on Contemporary Photography.* Seattle: Bay Press, 1990.

Szarkowski, John. *Looking at Photographs.* New York: Museum of Modern Art, 1973.

——. *The Photographer's Eye.* New York: Museum of Modern Art, 1966.

Tashiro, Charles. "Videophilia: What Happens When You Wait for It on Video." *Film Quarterly* 45 (Fall 1991), 7–17.

Trachtenberg, Alan, ed. *Classic Essays on Photography.* New Haven: Leete's Island Books, 1980.

Walton, Kendall. "Transparent Pictures: On the Nature of Photographic Realism." *Critical Inquiry* 11 (December 1984), 246–77.

Wartofsky, Marx W. "Cameras Can't See: Representation, Photography, and Human Vision." *Afterimage* vol. 7, no. 9 (April 1980), 8–9.

——. "Visual Scenarios: The Role of Representation in Visual Perception." In Margaret Hagen, ed., *The Perception of Pictures*, vol. II. New York: Academic Press, 1980.

Wheelock, Arthur K., Jr. *Jan Vermeer.* New York: Abrams, 1981.

Index

Memling, Hans, 19, 31, *33*
Mexican Migrant Workers, Highway in California (Meyer), 205, 206–7
Meyer, Pedro, 205, 206–7
Microsoft Art Gallery, 178, 180
Million Dollar Legs (film), 144
Minstrel Showbill, Alabama (Evans), 57–59, *58*
miracles. *See* animation
Miracles de Notre Dame (manuscript), 22
Mitchell, William, 178, 196, 197, 200
Models, The (Seurat), 26–28, *27*
Mona Lisa (Leonardo da Vinci), 161
Monkey Business (film), 140
montage. *See* collage; photomontage
Morgan, Barbara, 5, *6*
motion: in film, 129, 132–33; in paintings, 14, 17–20; in photos, 5, *6*, 65, 67, 81, 108–10, 207–9
Mouse Warming (cartoon), 142
Murray, Elizabeth, 161

Nasturtiums and "The Dance" (Matisse), 28, *29, 30*
Nativity, The (Christus), 31, *32*
Nègre, Charles, 44, 70, *71, 73*
New Look to Now (Pietri and Leventon), 68, *69*
Newman, Arnold, 76, *78*
Newman, Barnett, 162
New York, c. 1942 (Levitt), 76, *79*
Night Watch, The (Rembrandt), 177
Nude, East Sussex Coast (Brandt), 2, *3*

Our Festering Hands Ruin All . . . (Laughlin), 64, 65, 216n.19

paintings (billboards; drawings): animation in, 7, 14, 17–20, 22, 30–31, 42; attributes of, 110; beliefs about production of, 110, 114, 115, 121, 125, 126, 194–95; depiction of other artworks in, 11–20; differences between photos and, 7, 8, 87–111, 129, 152–53, 159–73, 183–84, 188–95; evaluation of, compared to photos, 49; as lacking photography's perceived connection with reality, 7, 8, 82–84, 85, 90, 100–104, 105–10, 114, 115, 121, 125, 128, 188–95, 208–9; perspective in, 162, 168–69; photographically untransmittable elements of, 155, 159–69, 174, 177, 182; photographic studies for, 93, 97, 110, 125; photographic transformation of, 2–5, 8, 51–62, 85–86, 151–84, 203–7; photography as influence on, 180–83, 190–93; trends in, 182. *See also* art; framing; photo-realism; surface; two-dimensionality vs. three-dimensionality
Pannini, Giovanni Paolo, 14
Panofsky, Erwin, 141–42
Peaches, Carafe, and Personage (Cézanne), 26
perceptual ambiguity: in film, 142, 143, 146, 148–49; in paintings, 24–31, 34, 35; in photos, 43, 53–54, 114, 216n.19
Petrole Hahn (Ringl and Pit), 76, *77*
Petrushka (ballet), 10, 145
Phillipot, Paul, 17–19
photographic reproductions, 8, 85–86, 151–84. *See also* duplication
photographs: altered, 2, 8, 118–28, 187–88, 195–209; ambiguity in, 40–45, 48–81; as art, 48–49, 182; art history's reliance on, 8, 153–57, 180–83; beliefs about production of, 7, 8, 49–50, 87–111, 114, 115, 121, 125, 126, 187–88,

Designer	Nola Burger
Compositor	Rainsford Type
Text	10/16 Scala
Display	Rotis Semi Sans, Regular and Bold
Printer and Binder	Maple-Vail